Born in the Spring

Born in $_{the}$ *Spring*

a collection of spring wildflowers
by June Carver Roberts

Ohio University Press, *Athens, Ohio*

Library of Congress Catalog Number LC 75-36979
ISBN 0-8214-0195-5 cloth
ISBN 0-8214-0226-9 paper

Printed in the United States of America

Designed by Don F. Stout

To Donald

CONTENTS

FOREWORD

For a number of years I lived at the edge of the Allegheny Plateau in Southern Ohio. It was during this time that I became aware that those who reside in or near this heavily-wooded, hilly country are privileged to enjoy a subtle and naturally unfolding botanical drama as each spring gradually (oftimes belatedly and hurriedly) blotted out the damp and dark of winter, and allowed the blessed greenness of reawakening plant life to spread slowly over the land. In these circumstances those who know and enjoy the study of plants came to recognize a natural annual rhythm in the appearance of the leaves and flowers of the various kinds of plants. They know that the wild flowers invariably appear in a definite sequence, and they learn in what habitats to look for them. Seeking out not only the native plants, but even the more attractive weedy ones becomes a yearly ritual which brings great satisfaction, a deeper enjoyment of spring, and adds a special dimension of pleasure to observing the reawakening life.

Born in the Spring is a book produced by a resident of that area who is very sensitive to this spectacle, who is anxious to share its delights with others. June Roberts has combined her talents as an artist and a keen observer of nature to interpret the spring flowers in ways that will bring them alive to her readers. With her beautifully realistic drawings of living specimens anyone who is really interested can recognize the spring-flowering herbaceous plants quite readily. Her crisp, faithful descriptions of each plant along with an abundance of interesting information such as when and where to look for the plants, and the salient characteristics useful in their identification reenforce in words the images wrought by her pen and her brush.

Perhaps I may be forgiven a personal observation. It must not occur too frequently that a college professor envisions a book like *Born in the Spring*, enlists a talented former student to help with it, then takes a new position in a far-distant area, and leaves the student totally abandoned with the project. Such is the story of the origin and development of this little book. I am delighted that Mrs. Roberts carried on the project to such a beautiful conclusion, and I am proud

that I may have had a small part in introducing her to the delights of spring botany. I am sure that she will be successful in advancing these interests for those who read and use this fine volume. They will find that it is not just another book on plants, but that it is a work that invites the reader to enjoy the delights of nature in spring and enable him to see and appreciate the infinite beauty of the wildlings of this season from aesthetic and artistic viewpoints, as well as from a soundly scientific base.

William G. Gambill, Jr.
Director, Denver Botanic Gardens
Denver, Colorado

PREFACE

This collection of drawings and paintings began several years ago when I was asked by Dr. William Gambill, a botanist, to do the illustrations for a field guide to spring wildflowers. After only 25 drawings were made, he was forced to abandon the project because he was offered a post elsewhere. Since I always enjoy excursions into the woods and fields, I decided to continue the wildflower drawings, at least until I had a more complete collection. Without the botanist I had to make my own identifications, and that became so fascinating and raised so many questions that I was soon doing more and more research.

A desire for answers that I couldn't find among books led me to ask Jean D. Wistendahl, another botanist, to assist me, for by that time I had decided to do a book of my own—not strictly a scientific field guide, but also a book that would describe in picture and word the wonder of these wildflowers and hopefully would serve as a plea for their protection. In the wild no one need water, mulch or feed the flowers, yet they will bloom year after year—if we but walk gently, look, and leave!

Our waysides are lovely from spring to fall with a succession of flowering plants, most of which are hardy aliens. These grow in a variety of soils and conditions, and seed-in even where land has been disturbed. On the other hand, our native wildflowers, especially those of spring, are often fragile and reclusive, requiring very special conditions—conditions that are now being greatly reduced by Man's encroachment upon wilderness—bogs, mature woods, riverbanks and streamsides. In his preoccupation with profit-making, Man often unknowingly does great damage to the very elements that make our planet so beautifully livable.

When I returned to a wooded hillside that had been lush with wildflowers every other spring to find it scraped bare by bulldozers, I was sure that those responsible had no awareness of what they had destroyed, or that that hillside was any different from many others. They were no more aware of what they destroyed than children picking endangered wildflowers, hikers and hunters tramping roughly through woods tearing tender roots from moist slopes or motorbikers whose wheels do total damage to roots *and* soil.

I hope that this book will provide a helpful guide to these spring wildflowers and enable its users to recognize a rare native as different

from a more common alien, so that an interest may develop to pre-
serve these and all our diminishing native wildflowers. Public interest
has saved other endangered species, and I am confident that it can
save the wildflowers.

<p style="text-align:center">* * * * *</p>

All the drawings and paintings were done from living flowers.
They are arranged chronologically, in order of their blooming in
southeastern Ohio, where I did the work. However, most of them are
to be found in the greater part of the northeastern and north central
states—those covered by Gray (Fernald), Britton & Brown, and
Rickett. (A list of the genera included, in the order of their logical
relationships by families, is provided at the back of the book.) The
times of blooming given are those for the southeastern Ohio region
and will vary slightly for other regions. Sizes indicated on the illus-
trations are those of the flowers I drew; size ranges for the species
are given in the text.

For the popular or common names of the flowers I chose the most
common from a variety of contemporary guide books. For the botan-
ical names I followed those in *Gray's Manual of Botany*, 8th edition
by M. L. Fernald (D. van Nostrand Co., 1970) exclusively. Botanical
names, I've discovered, are not the hopeless jumble of letters I once
thought them; in fact, pronouncing them, as with tricks, is easy once
you know how. Botanists are very relaxed about it and are totally
tolerant of Anglicized Latin.

To aid in pronounciation I have included accents in the headings;
these mark the syllable to be stressed as well as indicate the sound
of the vowel: the grave (`) accent indicates that the vowel is long, or
is said as we say the letter in the alphabet; the acute accent (´) indi-
cates the shortened or otherwise modified sound of the vowel. Ex-
ample: pày *vs* pát, bè *vs* bét, pìe *vs* pít, tòe *vs* tóp and cùe *vs*
cút. The only other part of the trick is with the ligatures; these were
originally linked together and given two sounds (a diphthong) but
are now written unjoined and pronounced as a single vowel having
the sound of the final letter. Thus *ae* and *oe* are both pronounced E,
ea is pronounced A and *eu* is pronounced U. Other than in ligatures,
every letter is sounded in Latin, even final e's; therefore the family
names ending in *ae* are pronounced E and those ending in *eae* are
unscrambled to be the letter e (said E) and the ligature *ae* (said E);
for example, the ending *ceae* is pronounced "see-y".

I have used botanical terminology only where clarity or brevity
required it and have provided a glossary of these terms.

<p style="text-align:right">J.C.R.</p>

ACKNOWLEDGMENTS

My very special thanks go to Jean Douglass Wistendahl, who gave unstintingly of her time to act as my botanical adviser, and to Elizabeth Parsons Warner, who read the manuscript and made valuable suggestions. For her conscientious help in preparing the manuscript I am indebted to Perry Barrio-Garay.

My grateful appreciation also goes to all the kind friends who directed me to flowers, helped with the typing and loaned me reference books from their libraries.

Aràceae: Arum Family

SKUNK CABBAGE
Symplocárpus foètidus (compound fruit) (fetid)

If, in February, you hear water trickling in the brooks and head for that sound of melting winter, you might find the first flower of Spring, the Skunk Cabbage—an inedible cabbage, but a remarkable plant. Buds having formed in the fall, the tough, pointed spathes now pierce the frozen ground, melting their way through with their own living heat. Growing in swampy areas from stout perennial root-stocks, each flower rises out of the mud 2 to 6 inches, mottled with yellow-green and purple-red, and subtended by pale green bracts. Down inside the spathe, protected by it as by a heavy cowl, stands the pale spadix, symetrically studded with the minute creamy-yellow true flowers. The spadix is ovoid, about 1 inch across, 1¼ inches high and ¾ inch through.

When the spathe begins to wither, the tufts of cabbagelike leaves appear, at first rolled into fat fingers, later opening to stand 2 to 4 feet high on long stalks, with blades 1 to 2 feet across—unlike the leaves of most monocotyledons, having a network of veins. Rising in conspicuous crowns, they catch the light and the eye all summer. The fruit is formed from the spadix, which enlarges into a spongy mass up to 6 inches in diameter, with spherical seeds just beneath the surface.

Symplocarpus foetidus is a worker, and a welcome one; therefore, no one minds that it smells like a skunk in all its parts, most noticeably when crushed or broken. The first insects of spring are attracted by this odor, and effect pollination.

A circular section has been cut away to reveal the spadix in the large Skunk Cabbage in the illustration.

FEBRUARY NATIVE

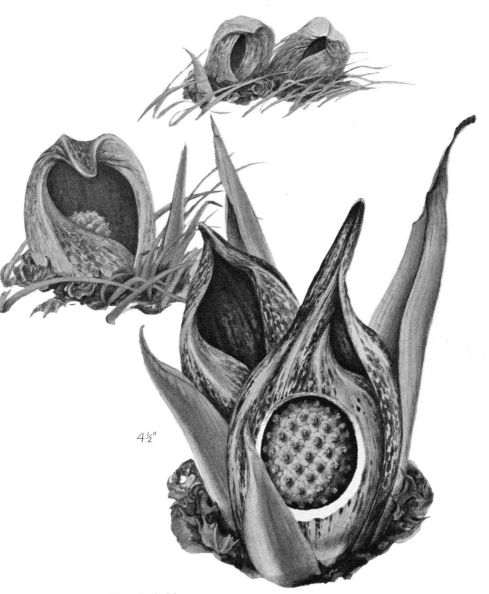

4½"

Skunk Cabbage

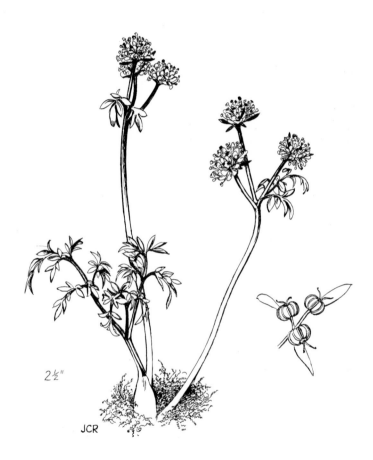

2½"

JCR

Harbinger-of-spring

Cruciferae: Mustard Family

PENNSYLVANIA BITTERCRESS, EARLY CRESS

Cardámine pensylvánica (heart-strengthening) (Pennsylvanian)

In early March, when any sign of spring is welcome, this insignificant biennial may be noticed in lawns and fields as it begins to put up flower-stalks 2 to 10 inches high. Rosettes of basal leaves have been green all winter, and tasting similar to watercress, could have freshened a salad or sandwich any time between December and February. Now, however, in March, the leaves are too tough for eating but we welcome its flower. As in all the cresses, Pennsylvania Bittercress has four early-falling sepals, four petals, six stamens with two shorter than the other four, and one pistil. The leaves are pinnately divided with the end segment largest and rounded. The stems are slightly bristly at the base, as is the basal rosette of leaves.

By mid-April we have seen many lovelier wildflowers and may begin to look upon the plainer Pennsylvania Bittercress as a weed in our yard; but it has a way of surviving our fickleness. As the tiny white flowers open successively from the top, the stalk grows taller, now reaching 4 to 18 inches; long narrow pods form quickly as the flowers fade, and when ripe, they pop open from the base with such elasticity that the seeds are thrown in all directions—the slightest touch triggers this explosion, foiling any attempt to "weed them out" at this time—and next winter's bed of greens is assured.

EARLY MARCH NATIVE

Gentianàceae: Gentian Family

PENNYWORT

Obolària virgínica (obolus) (Virginian)

Pennywort is a moist woodland perennial of late March, difficult to see until close at hand, as it is a small plant, rising above the dead-leaf litter only 3 to 7 inches and almost matching it in color. It has a curious lack of leaves—there are scales on the lower stalk and round, folded, bronzy-green bracts above in whose axils the white or pale lavender flowers nestle. The stem is simple or sparingly branched.

Obolaria virginica is said to be partly saprophytic, meaning it gains much of its nourishment from dead and decaying vegetation. The generic name came from the rounded bracts' resemblance to a small Greek coin, *obolus.* This is the only species in this genus, and it occurs only in northeastern United States.

LATE MARCH NATIVE

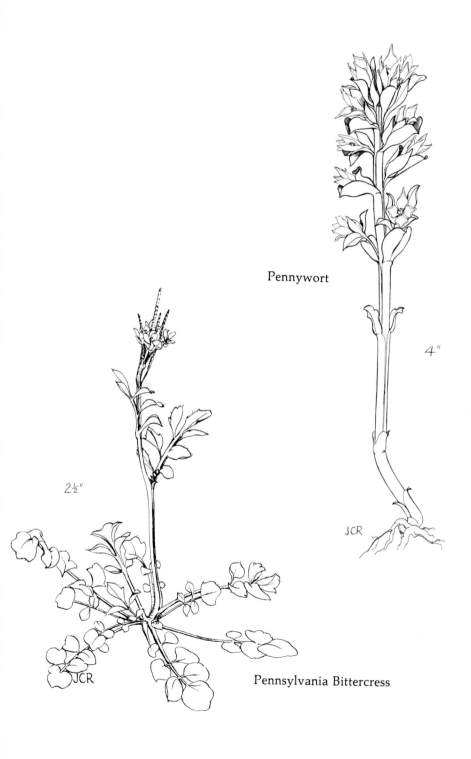

Pennywort

4"

JCR

2½"

JCR

Pennsylvania Bittercress

Ranunculàceae: Buttercup Family

ACUTE-LOBED HEPATICA, LIVERLEAF
Hepàtica acutíloba (liver) (acute-lobed)

Migrating birds begin to return in mid-March, and grass may be greening, but winter still camps in the woods and Hepatica seems fragile indeed to be blooming—only the tough little Harbinger-of-Spring and the woody Spicebush might have bloomed there before it—yet once sprouted, encouraged by a few mild days, Hepatica withstands cold and even snow, which inevitably returns at least once more. Perhaps that is why clumps of Hepatica almost always grow in sheltered places: under a hill, against a rock or at the base of an old tree; the search of such spots is well rewarded if Hepatica is found, for the colors and textures of bark and rock are perfect settings for its pastel delicacy.

The petal-like sepals may be lavender, blue, pink or white; some are mildly fragrant. Three sepal-like bracts are green; the stamens are numerous, the pistils several. A group of flowers rises, each on its own hairy stalk, 3 to 9 inches high, from a clump of last year's leaves that are often not apparent among the dead oak and maple leaves. When young, the flowers close at night, but older ones remain open. While they are blooming, the new leaves appear, rolled inward and thickly covered with white, silky hairs; as they unroll, the hairs are on the underside. In *Hepatica acutiloba* the leaves are divided into three pointed lobes; their upper surface is smooth and dull dark green tinged with reddish-purple at the edges. By late fall, exposed leaves will have become entirely purple, protected ones may remain green —in this state they persist through the winter. Spring-beauty, Lavender Bittercress and Cut-leaf Toothwort may bud and open in the same area while Hepatica is blooming.

The name *Hepatica* is from the Greek for liver and was given to the genus due to the leaves' resemblance to the shape of the liver (more likely the round-lobed species). Once used to treat liver ailments, it is an example of the "doctrine of signatures" of ancient times, when it was believed that "God hath imprinted upon the Plants, Herbs and Flowers, as it were in Hieroglyphichs, the very Signature of their Virtues." Thus did Robert Turner state the doctrine in 1664. By the sixteenth century the theory was repudiated by the best herbalists (Core).

Hepatica is listed as being in need of preservation by the Ohio Department of Natural Resources and is on a recent list of rare and endangered species (Wistendahl et al., 1975).

ROUND-LOBED HEPATICA, *Hepàtica americàna* closely resembles *H. acutiloba*, but its leaf lobes are round and its flowers are somewhat smaller.

MID-MARCH NATIVE

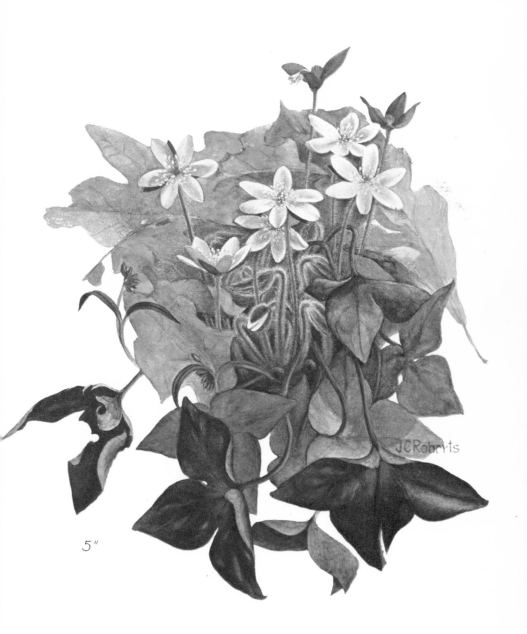

5"

Acute-lobed Hepatica

24

Compósitae: Composite Family

COLTSFOOT, COUGHWORT
Tussilàgo fárfara (cough) (coltsfoot)

The sunniest of yellows is the flower of Coltsfoot, when in mid-March it first brightens roadsides and moist banks still brown with winter's dead leaves. The rays and disk are both deep yellow, with outer bracts of reddish-purple. The flower stem is pale, and scaly like an asparagus stalk, 2 to 5 inches high when the single bud at its summit begins to open. As the flower ages, the stem stretches taller, and by fruiting time it may reach 12 to 18 inches.

The fluffball of white pappus bristles resembles that of a large dandelion, but a closer look will reveal the scaly stem and, a little later, the woolly young Coltsfoot leaves coming out of the ground nearby. By summer these will be 3 to 7 inches across on long stalks, smooth above and white woolly beneath. They are somewhat the shape of a colt's hoof-print (hence the common name) and are easily identified, even from a distance, by their habit of grouping to form solid patches of vivid green. The leaves last all summer and well into fall, for the plant is perennial, rising from a horizontal creeping rootstock.

Tussilago farfara has been introduced from Europe and Eurasia, where Coltsfoot tea or syrup is believed to relieve coughs and colds; *tussis*—Latin for "cough"—is the word from which the generic name was derived; recipes for the syrup and tea can be found in most herbals. Apothecaries in Paris once painted Coltsfoot flowers on their doorposts as a symbol of their trade.

MID-MARCH ALIEN

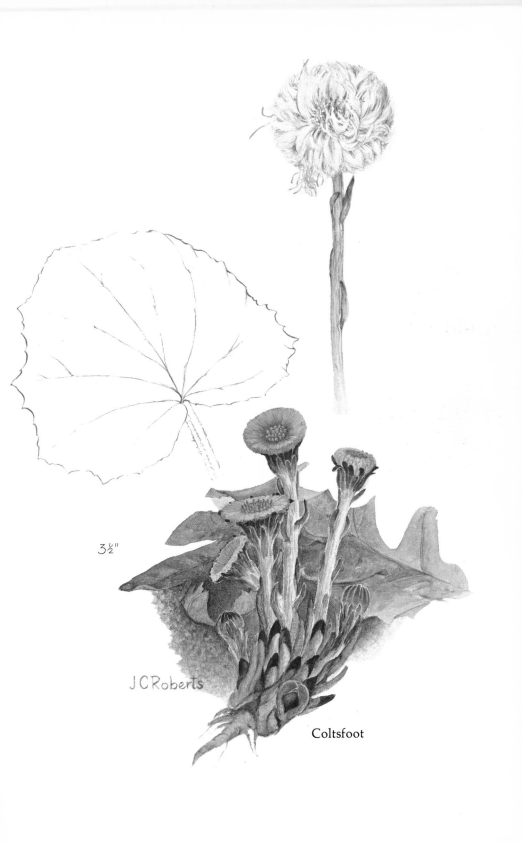

3½"

J C Roberts

Coltsfoot

Portulacàceae: Purslane Family

VIRGINIA SPRING-BEAUTY
Claytònia virgínica (J. Clayton) (Virginian)

In late March this pink-striped beauty blooms profusely in moist woods where Hepatica may be blooming, Cut-leaf Toothwort may be budded and the lacy leaves of Dutchman's-breeches may have begun to show. It also marches right into towns, scattering pink across lawns here and there. The flowers are ½ inch across, pink or white with darker pink veins and soft pink anthers, in a false raceme that uncoils as it opens. There are two persistent sepals, five petals, five stamens and a pistil whose style is three-cleft at the apex.

The two thick, slender leaves are opposite, midway up a smooth fleshy stem that somewhat reclines below the leaves. Basal leaves, if present, are similar to the stem leaves. Spring-beauty closes at night and on dark days, making sure to keep its pollen dry.

Claytonia virginica is perennial, growing from a deep-seated tuber to a height of 12 inches by the time the last bud has opened in May. The fruit is a three-valved capsule with three to six seeds. The generic name honors one of our earliest American botanists, John Clayton, who died in 1773.

CAROLINA SPRING-BEAUTY, *Claytònia caroliniàna*, is similar but has much broader leaves and a stouter stem with fewer flowers.

LATE MARCH NATIVE

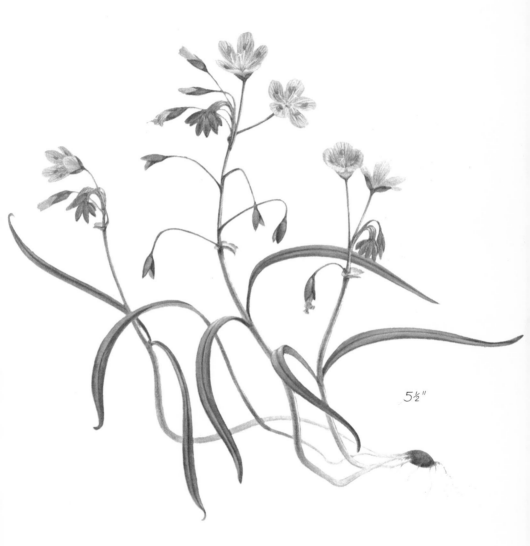

5½"

Virginia Spring-beauty

Caryophyllàceae: Pink Family

COMMON CHICKWEED
Stellària mèdia (starlike) (intermediate)

Chickweeds are common, sprawling plants that carpet the ground with their slender, weak stems, opposite leaves and starry white flowers. The most common, *Stellaria media* is a winter-growing annual in damp lawns, gardens, fields, woods and roadsides, blooming in any favorable weather, but profusely in early April. The five petals, so deeply cleft that there appear to be ten, are shorter than the calyx. There are usually ten stamens, having white filaments with maroon anthers and three styles.

The leaves are an inch or less long; upper ones are sessile; lower ones are petioled. Fine hairs file down the stems in straight lines.

The Chickweeds were so named because the seeds and leaves are eaten by small birds. In Europe, some species of Chickweed were mentioned in old herbals as nutritious cooked greens, low in calories and high in vitamin C.

FIELD CHICKWEED, *Ceràstium arvénse* is a native species whose petals are twice as long as the sepals, or longer, and are notched rather than cleft. The plant may be smooth, sticky or hairy.

EARLY APRIL ALIEN

Berberidàceae: Barberry Family

TWINLEAF
Jeffersònia diphýlla (T. Jefferson) (two-leaved)

At the end of April the distinctive leaves of this woodland perennial are large and conspicuous, but by that time the flowers are gone for another year. If we've missed them, the leaves will give us a clue where to look next spring about the first of April. The solitary white flower is about an inch across on its own scape, fragrant and ephemeral. There are four early-falling sepals, eight petals and eight stamens (sometimes seven or nine).

A clump of flowers and immature leaves stands only 4 to 9 inches high, the flowers usually exceeding the leaves, which are deeply divided into two winglike segments on a long stalk that may be 16 to 20 inches high when full grown. The stalks are reddish-gray and the leaves are blue-green above, frosty white beneath, and edged with a fine red line. The fruit is an upside-down pear-shaped pod whose side opens mouthlike to discharge its shiny chestnut-brown seeds.

Jeffersonia commemorates Thomas Jefferson, who was an ardent student of all the sciences. It is interesting that there are only two species of *Jeffersonia*, one growing in eastern North America and the other in eastern Asia—also the only two areas in the world where colored foliage occurs in the fall.

EARLY APRIL NATIVE

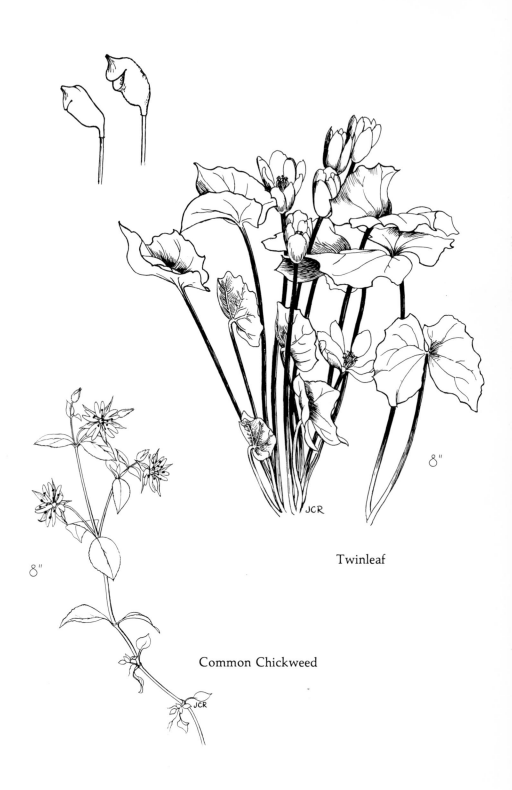

8"

Twinleaf

8"

Common Chickweed

30

Crucíferae: Mustard Family

CUT-LEAVED TOOTHWORT, THREE-LEAVED CRINKLEROOT
Dentària laciniàta (tooth) (slashed)

Toothwort, unlike many members of the mustard family, is a
lovely wildflower with petals ½ inch to an inch long. This earliest
Toothwort blooms in damp woods at the beginning of April. A sturdy
perennial standing erect 7 to 15 inches high, its flowers are pink-
lavender or white in a terminal cluster, the four petals spreading to
form a cross, from which the family gets its name. Also characteristic
of the family are the six stamens of which two are shorter than the
other four.

The three tough, green leaves of Three-leaved Toothwort grow
in a whorl, or nearly so, midway up the stalk; each leaf is usually
deeply cut into three narrow leaflets with toothed margins, although
the foliage of this plant is exceedingly variable. Often the young leaves
are tinged with purple.

The plant grows from a succulent, pungent rootstock; in some
species it is crinkled, hence the common name Crinkleroot. The fruit
is a flat pod, 1 to 1½ inches long.

TWO-LEAVED TOOTHWORT, *Dentària diphýlla*, resembles *D.
laciniata* but has two long-petioled basal leaves and usually two stem
leaves, each divided into three toothed segments.

EARLY APRIL NATIVE

Crucíferae: Mustard Family

LAVENDER BITTERCRESS
Cardámine douglássii (heart-strengthening) (D. Douglass)

Another good-looking member of the mustard family, Lavender
Bittercress has a raceme of showy pale lavender or white flowers that
are very sweet smelling. Each has four petals in a cross, six stamens
and one pistil. The stem is tender and slightly hairy; blue-green leaves
grow from it without stalks; basal leaves have long stalks. A woods
flower, Lavender Bittercress blooms in early April and for several
weeks thereafter, often side-by-side with Cut-leaf Toothwort and
Spring-beauty, and soon to be followed by Dutchman's-breeches,
Trillium and Troutlily—the parade has begun.

Cardamine douglassii is perennial, reproducing by tubers and by
seeds borne in long, narrow pods that spring open from the base.
The generic name arose from an early belief that some cresses had
heart-strengthening properties. There are twelve species of Bittercress;
this one is named for its discoverer, the botanist David Bates Douglass,
who lived from 1790 to 1849.

SPRING CRESS, *Cardámine bulbòsa*, is very similar but blooms in
May, has white flowers and is not hairy.

EARLY APRIL NATIVE

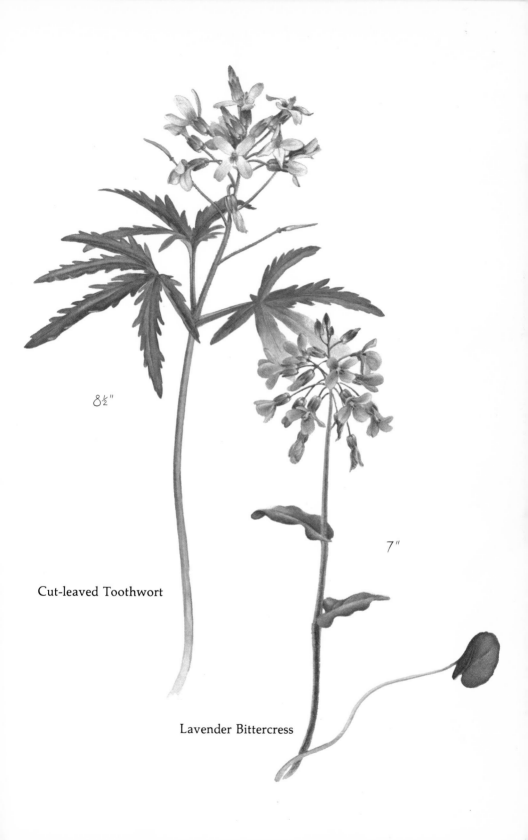

$8\frac{1}{2}''$

$7''$

Cut-leaved Toothwort

Lavender Bittercress

Limnanthàceae: False Mermaid Family

FALSE MERMAID
Floèrkea proserpinacoìdes (Floerke) (like Mermaid-weed)

Most of us know False Mermaid not by the individual plant, but as a thick low mat of finely textured yellow-green on damp woods floors and riverbanks. It leafs out early and seems to take upon itself the job of covering the brown of winter as quickly as possible with its fresh, new color. It and Chickweed seem to divide the ground between them, seldom growing in the same area. In early April False Mermaid bears a miniature flower, of a slightly paler green than the leaves; it has three sepals, three petals and six stamens, and is borne singly on slender stems in the axils of the leaves.

The plant was named for Heinrich Gustav Floerke, a German botanist who lived from 1764-1835.

EARLY APRIL NATIVE

Papaveràceae: Poppy Family

BLOODROOT, RED PUCCOON
Sanguinària canadénsis (bleeding) (Canadian)

Possibly as early as late March and all through April the rhizomes of Bloodroot send up flower and leaf pairs 4 to 9 inches high from moist banks and woods' edges. The solitary blossom is enveloped in its single leaf, which in turn is wrapped in papery bracts; thus the bud and leaf are kept safe and clean until they escape the wet ground. The leaf remains cupped around the flowerstalk in a protective gesture, but pulls back enough to let the erect bud push ahead, opening into the brilliant white, eight-petaled bloom with its golden center of 24 stamens and one pistil—a lovely, fragrant, but transitory flower that surrenders to wind or rain in a day.

The leaf then takes the stage, opening out and growing larger to show its handsome lobed margin, strong veining and soft yellow-green color that is somewhat paler beneath. The flowerstalk also grows taller as the pistil matures into fruit.

The rhizome of *Sanguinaria canadensis* has an acrid red-orange juice that "bleeds" when it is cut or broken. In former times it was used as an astringent and cure for ulcers and ringworms. "Puccoon" is from an Algonquin Indian word for certain plants, especially the Poppies, from which the tribe obtained red and yellow dyes for staining their faces.

This is the only species in this genus, and it grows only in northeastern United States. It is disturbing to find it on a recent list of rare and endangered species (Wistendahl et al., 1975).

EARLY APRIL NATIVE

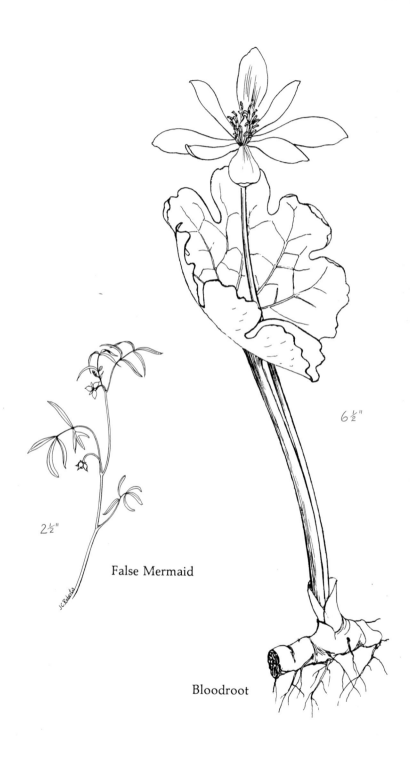

$6\frac{1}{2}''$

$2\frac{1}{2}''$

False Mermaid

Bloodroot

Saxifragàceae: Saxifrage Family

EARLY SAXIFRAGE
Saxifraga virginiénsis (to break a rock) (Virginian)

Growing in colonies on rocky slopes or following along the smallest cracks in ledges, this dainty annual must play a part in rock disintegration; however, according to Gray, the name applied, through the "doctrine of signatures" (see *Hepatica acutiloba*), to a European species bearing granular tubers—"stones"—on their roots, which were believed to dissolve kidney stones.

The thick, hairy scape rises from a rosette of hairy basal leaves, slimming to culminate in a branched inflorescence of small white flowers in tight clusters that develop into an open panicle. Each flower has five petals, ten yellow stamens and one pistil with two styles. The two-beaked seedpod is purple-brown and contains the numerous seed necessary for the risky business of being an annual.

The leaves are soft gray-green, woolly and usually scalloped at the edge. The plant is 4 to 12 inches high at blooming time in mid-April, while Dutchman's-breeches, Bloodroot and Rue-Anemone are also blooming.

MID-APRIL NATIVE

Papaveràceae: Poppy Family

DUTCHMAN'S-BREECHES
Dicéntra cucullària (two-spurred) (hoodlike)

The delicate Dutchman's-breeches returns each April to the rocky, wooded hillsides where it is established—unless, of course, bulldozers interfere. The fragrant white flowers with yellow lips hang from a gently-arching stalk that is 4 to 9 inches high. There are two pairs of petals, the outer two enclosing the inner two and seeming to form a firmly closed flower. Can insects enter? In her book of 1893, *How to Know the Wildflowers*, Mrs. William Starr Dana mentions gauze being placed over Dutchman's-breeches to exclude insects, with the result that no seed was set. The conclusion was drawn that insects must enter, since the plant obviously reproduces by pollination.

The finely-cut leaves of *Dicentra cucullaria* are pale blue-green, their stems also arching to hold the leaves spread beneath the flowers. The leaf and flower stems all rise from a cluster of little white to pink tubers just under the ground. Three-leaf Toothwort, Spring-beauty and Twinleaf may be found blooming in the same area.

SQUIRREL-CORN, *Dicéntra canadénsis*, is often found in the same habitat, but it differs from *D. cucullaria* in having a corolla with short, rounded spurs like the top of a heart, and tubers the shape and color of kernels of corn. It blooms a little later than *D. cucullaria*.

MID-APRIL NATIVE

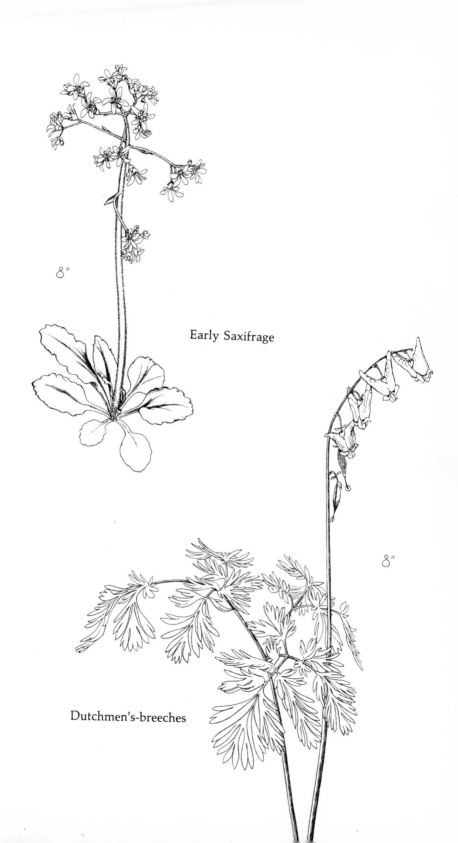

8"

Early Saxifrage

8"

Dutchmen's-breeches

Compósitae: Composite Family

COMMON DANDELION
Taráxacum officinàle () (of the shops)

This ubiquitous weed of lawns and grassy ground means something to almost everyone. Children pick the golden flowers without being admonished, and most of them have split the hollow stems to make Dandelion curls. Adults may gather the blossoms to make Dandelion wine or descend upon young Dandelions in March with paring knives and weed-pruners to dig them—a double duty job if the weeded leaves are eaten in a salad, cooked or canned. Some people go for the deep taproot, as that is the only way to rid the lawn of the plant permanently and also is a way to arrive at a coffee substitute made from the dried roots. Last but not least, wildlife eat the flowers, leaves and seeds.

The many-flowered heads have two rows of bracts beneath them. These spread horizontally when the flowers open, then rise vertically for a week or so while the achenes ("seeds") develop, then spread again and eventually become reflexed against the stem to expose the ball of pappus bristles now ready to carry the mature achenes on the wind. At this stage the war is over and the day is theirs—one may as well stand in admiration.

Taraxacum is an old Arabic name; *officinale* refers to the fame the plant once had in medicine, when the milky alkaloid juice was sold as a mild laxative and tonic.

MID-APRIL ALIEN

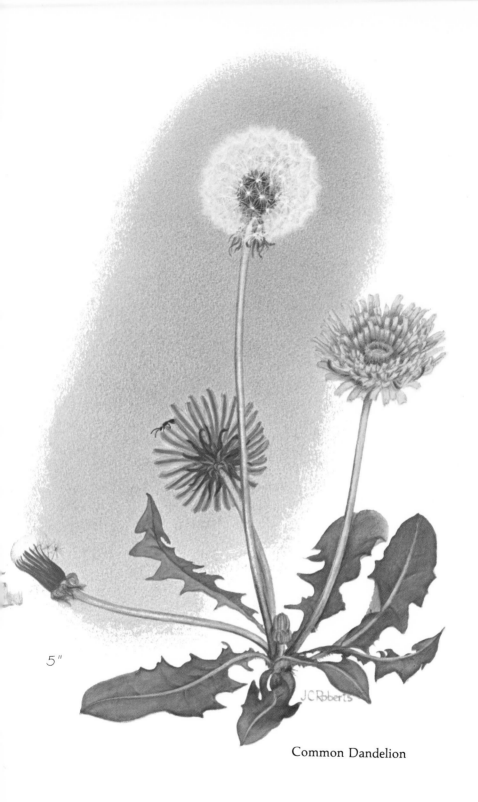

5"

J C Roberts

Common Dandelion

38

Ranunculàceae: Buttercup Family

RUE-ANEMONE

Anemonélla thalictroìdes (little Anemone) (like Meadow-Rue)

A perennial that grows from thick, tuberous roots to stand 6 to 8 inches high, Rue-Anemone begins blooming in mid-April in open woods, and continues for a month or more. The delicate white, or occasionally pink, flowers have dark, wiry stems, numerous stamens with yellow tips, and several pistils. The leaves are divided into smooth, rounded leaflets resembling those of Meadow-Rue *(Thalíctrum dioìum);* the flower resembles that of the Wood-Anemone *(Anémone quinquefòlia)*—thus it was named.

Note: The above description dodges the following interesting botanical complexities: 1) There are no petals; the five to nine showy sepals take their place. 2) What seem to be six leaves just under the flowers are in fact two bracts, each divided into three stalked segments. 3) The two basal leaves, which come after the flowers, are also made up of three stalked leaflets.

MID-APRIL NATIVE

Violàceae: Violet Family

SMOOTH YELLOW VIOLET

Vìola pensylvánica (Violet) (Pennsylvanian)

Smooth Yellow Violet begins to bloom in damp woods, thickets or lowlands in mid-April, often among Blue Violets, Troutlilies and Dutchman's-breeches. The erect stem is smooth and branched, bearing both leaves and flowers and reaching 4 to 12 inches. The flower has five yellow petals, the three lowest ones marked with brown lines—a "honey-guide" for the insects that will deposit and carry away pollen in exchange for nectar. As in all the violets, the central, lowest petal extends into a hollow sac or "spur" that holds the nectar-bearing stamens.

The leaves are heart-shaped and smooth, stem leaves having short stalks while the one to three basal leaves have longer stalks. The stipules are entire or fringed, not toothed. White woolly hairs cover the plump capsules.

An interesting feature of many of the violets is the cleistogamous flowers—inconspicuous, self-fertilizing blooms that never open and are near or under the ground. They form capsules that bear an abundance of assured seed and help to keep the species separate; the pollinated ovaries tend to hybridize.

MID-APRIL NATIVE

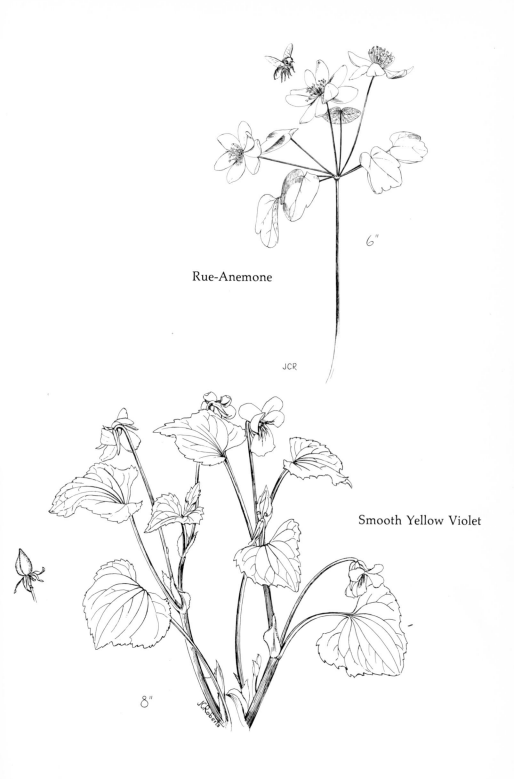

Rue-Anemone

6"

JCR

Smooth Yellow Violet

8"

JCRoberts

Equisetàceae: Horsetail Family

FIELD HORSETAIL
Equisètum arvénse (horse bristles) (of cultivated fields)

Horsetail is a rushlike plant that does not flower, but reproduces by spores, and is fascinating in color and form. The annual, fertile stems rise from perennial rhizomes in sandy or gravelly soil. They are pink or tawny, with narrow furrows and cylindrical, toothed sheaths at the nodes. In mid-April, conical fruits form at their tips, composed of shield-shaped discs on stalks that lift up and out, as louvers do, to discharge the many gray-green spores from the spore-cases beneath. The discs are green to ochre, and the spore-cases edging them are almost white—at this stage the plant appears to be in flower. Each microscopic, green spore is a ball with four spiral bands wound around it that uncoil and propel the spore when they absorb moisture.

After the fertile stalk dries, the sterile shoots spread their green branches, which are set in whorls at the nodes. Rough, due to being three-angled, and jointed, each section fits into the toothed end of the preceding one. (They can easily be pulled apart like children's pop-beads.) These branches are rich enough in chlorophyll to manufacture all the food the plant needs; therefore, the leaves have become obsolete.

MID-APRIL NATIVE

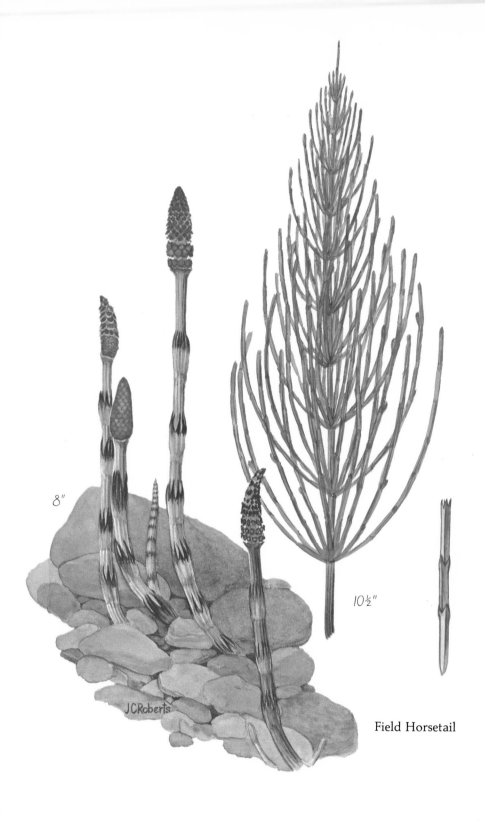

8"

10½"

J C Roberts

Field Horsetail

42

Rosàceae: Rose Family

INDIAN STRAWBERRY
Duchèsnea índica (A. Duchesne) (Indian)

A native of Asia, the Indian Strawberry is distinguished from the edible Wild Strawberry by having yellow flowers and three-toothed bracts that alternate with and are longer than the sepals. The leaf is divided into three segments with toothed margins, and the fruit resembles a strawberry in appearance, but the "seeds" (in this case the achenes) are on raised knobs instead of on the surface of the fruit as in Wood Strawberry, or sunken into it as in Wild Strawberry. This fruit is dry and tasteless to us but seems to be greatly enjoyed by birds.

The leaves and flowers rise at intervals from creeping stems to a height of 2 to 5 inches in fields and grassy places, flowering in mid-April. The generic name is for Antoine Duchesne, a French botanist who died in 1827.

MID-APRIL ALIEN

Rosàceae: Rose Family

CINQUEFOIL
Potentílla canadénsis (little potent one) (Canadian)

Potentilla is a large genus of plants whose flowers have five petals, five sepals and five bracts alternating with the sepals. The leaves often have five segments* as well (Cinquefoil means five leaves.), but not always. This species does have five-segmented leaves whose edges are toothed around the top and halfway down the sides. (A similar species, *P. símplex*, has leaf-segments that are toothed three-fourths their length.) There are many achenes collected in a head on a hairy receptacle.

Cinquefoil is a low creeping plant, common on dry soil. The flower is bright yellow, ¼ to ½ inch across, solitary and borne on a stalk that grows from the axils of the leaves; it is distinguished from a Buttercup by the five bracts alternating with the sepals.

The plant is 4 to 6 inches high at flowering time in mid-April; then, as the reddish stems elongate, the tips touch the ground, root and send up new plants.

Potentilla was named for the medicinal powers of a European species cultivated for food in ancient times.

*A leaf segment (or leaflet) is distinguished from a leaf by examination of the leaf trace (vascular bundle) under a microscope.

MID-APRIL NATIVE

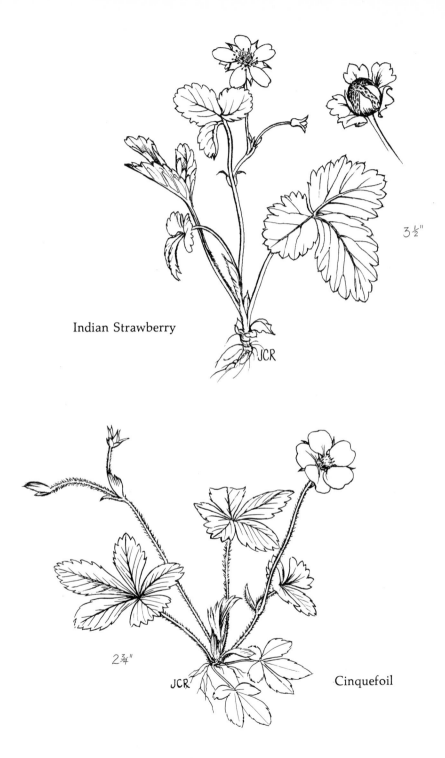

Indian Strawberry

$3\frac{1}{2}''$

$2\frac{3}{4}''$

Cinquefoil

44

Crassulàceae: Orpine Family

WILD STONECROP
Sèdum ternàtum (to sit) (in threes)

There are over 200 members of the genus *Sedum,* all hardy, low plants adapted to survive in various unfavorable conditions—heat, cold, rocks, etc. *Sedum ternatum* grow in colonies on calcareous rocks and ledges, sitting on the ground, as the name suggests.

Prostrate sterile branches with rounded succulent leaves have terminal rosettes; fertile branches arise from these, curving upward to a height of 3 to 6 inches, their lower leaves in whorls of three, their upper leaves alternate and sessile. In mid-April these hold the three-forked cyme of white flowers. Wild Stonecrop is native throughout the Northeast. Originally it was not found in New England, but was cultivated there and has since escaped into the wild.

MID-APRIL NATIVE

Compòsitae: Composite Family

PLANTAIN-LEAF PUSSYTOES
Antennària plantaginifòlia (antennaelike) (plantain-leaved)

An apt common name was given this early everlasting, for when young, its flower heads look and feel like miniature cats' paws. They are clustered together at the top of the pale, webby stem and are made up of small, closely crowded tubular flowers. The sexes are on separate plants: the pistillate plant has dull white or tan flowers, later showing crimson styles; the staminate plant is smaller with dull white or pink flowers.

The basal leaves, oval with three unbranched ribs somewhat like plantain leaves, lie in overlapping rosettes, each leaf about 2 inches long, hoary gray-green above, silvery white beneath. Stem leaves are lance-shaped and smaller, becoming more so and fewer toward the top. Branches from the base of the plant start new plants, resulting in tightly packed colonies. The flowering stalks are 3 to 18 inches high, first appearing in mid-April.

Pussytoes accomplishes the job of growing in arid, sterile places to begin the building of richer soils that can support more showy plants. There are many species or variations of *Antennaria,* all having the same basic characteristics. The name comes from the resemblance of the pappus to the antennae of certain insects.

MID-APRIL NATIVE

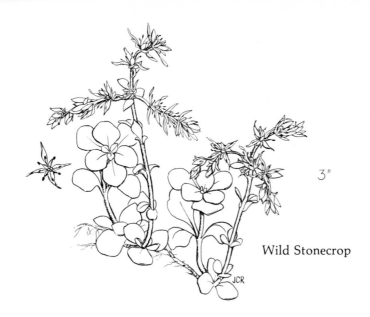

3"

Wild Stonecrop

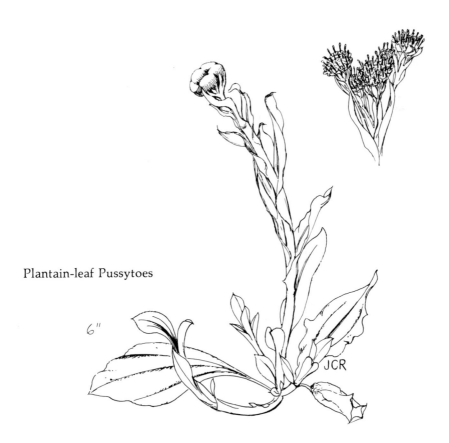

Plantain-leaf Pussytoes

6"

Liliàceae: Lily Family

TOAD TRILLIUM, STEMLESS TRILLIUM
Tríllium séssile (three in a whorl) (stemless)

The damp woods of mid-April are already adorned with Spring-beauty and Dutchman's-breeches when Toad Trillium first appears. The trees overhead, now budded, will be in full leaf before its long blooming season is over. Growing 4 to 10 inches tall from an underground rootstock, it has an erect stem holding three broad sessile (stalkless) leaves in a whorl and a sessile flower on top. The petals are upright and maroon; the sepals are green and the broad leaves are mottled with maroon or dark green—there are three of each. Aberrant forms of this species are often found. Its unusual shape and color make Toad Trillium a favorite of mine in spite of its slightly unpleasant odor.

The fruit is a six-angled red berry holding many seeds that take two years to germinate; the seedlings then require two to three years more to produce flowers—no Trillium should ever be picked.

Wake-robin is another name for Trillium.

MID-APRIL NATIVE

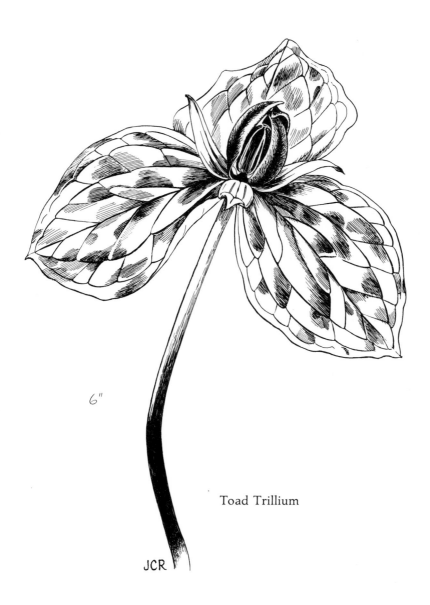

6"

Toad Trillium

JCR

Boraginàceae: Borage Family

VIRGINIA BLUEBELLS, VIRGINIA COWSLIP
Merténsia virgínica (F. Mertens) (Virginian)

For such a lovely flower to have only inaccurate common names seems a shame, especially since it is not even in the same family as English Cowslip nor in that of Scotch Bluebell. Nevertheless, the plant is so admired it is often cultivated. Its trumpet-shaped blossoms hang in a coiled false raceme of pink buds that turn lavender as they stretch, then blue as the flowers fully open. Each flower is approximately 1 inch long; there are five stamens and one pistil.

The plant is succulent, smooth and glaucous, ranging from 1 to 2 feet high. The stem and leaves are cool green, the stem leaves either short-stalked or sessile, while the leaves of basal shoots are long-stalked. *Mertensia virginica* is an inhabitant of moist soils, in the open or in shade, blooming in mid-April. It is now in need of preservation and is listed as such by the Ohio Department of Natural Resources.

The generic name is for Franz Mertens, a German botanist, who died in 1831.

MID-APRIL NATIVE

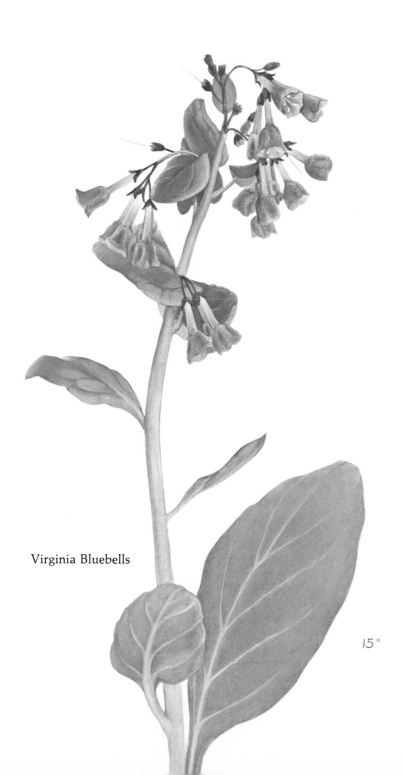

Virginia Bluebells

15"

Liliàceae: Lily Family

YELLOW TROUTLILY, YELLOW DOG'S-TOOTH VIOLET, YELLOW ADDER'S-TONGUE, YELLOW FAUNLILY

Erythrònium americànum (red) (American)

From a small, white bulb the size of a "dog's tooth" rise the paired leaves and short flower-stalk of the handsome Yellow Troutlily. It reproduces by seed and by new bulbs that form from thin, white underground branches. New bulbs send up only single leaves for three to six years before producing flowers.

The blossom is a large, solitary, nodding bell at the top of the 5 to 9 inch flower-stalk. The three sepals and three petals are deep yellow, spotted with brown inside and washed with bronze outside; they curve outward and upward leaving the six long, red-brown or yellow anthers and the single pistil protruding from the bell downward and hence underneath it. At night and on dark days the perianth uncurls and hangs down, protecting the pollen from dew and rain.

The smooth, thick leaves are mottled with greens and bronze—the "trout" of the common name. The plant favors moist, thinly wooded flats and slopes, blooming in mid-April. It is found in colonies or dispersed through woods among Dutchman's-breeches and Yellow Violets. The seed capsule is three-angled with the style persisting.

The American naturalist, John Burroughs (1837-1921) gave it the names Troutlily and Faunlily, being dissatisfied with the name Violet for a Lily. *Erythronium* originated with a purple flowering European species.

MID-APRIL NATIVE

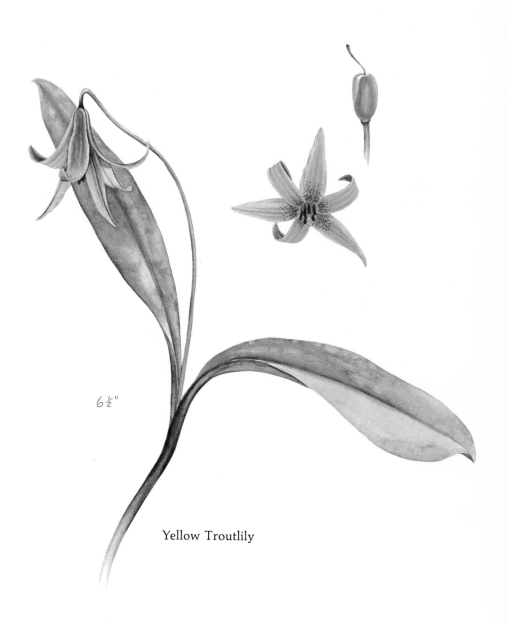

6½"

Yellow Troutlily

52

Crucíferae: Mustard Family

WINTER-CRESS, YELLOW ROCKET
Barbarèa vulgàris (St. Barbara) (common)

The racemes of lemon yellow flowerets on the branching stalks of Winter-Cress first appear in mid-April. Each floweret has four petals, six stamens and one pistil, which matures into a seedpod with a short beak (see *Dentaria laciniata* for more on this family). Small lobed leaves clasp the stem; lower leaves are elongated and have "ears." After the flowers, a rosette of basal leaves develops and remains green all winter, a treat for wild greens gatherers in February and March, when they are best for eating; after the nights grow warm, they become bitter. The plant grows 1 to 2 feet tall.

An immigrant from Europe, *Barbarea vulgaris* is now established in fields and along roadsides over all North America except the extreme south. Bright yellow rectangular patches seen on the countryside in May are likely to be whole fields abloom with this mustard. It was named after St. Barbara because the seeds of the European cultivated species were always sown on her day in spring.

MID-APRIL ALIEN

Malvàceae: Mallow Family

COMMON MALLOW, CHEESES
Málva neglécta (emollient) (overlooked)

An annual or biennial creeping weed, the Common Mallow was introduced from Europe and is now found in waste places throughout the North American continent blooming from April through October. The flowers are rose, lilac or white, deepest at the edges of the petals. There are five sepals and five petals twice as long as the sepals; the stamens are joined together into a hollow column around the styles, which project through it. The carpels, about fifteen, are arranged in a ring resembling a Dutch cheese; each one-seeded carpel is shaped like a slice from the ring.

The cultivated hollyhock and hibicus are members of this family. Malva is said to refer to the emollient leaves.

APRIL ALIEN

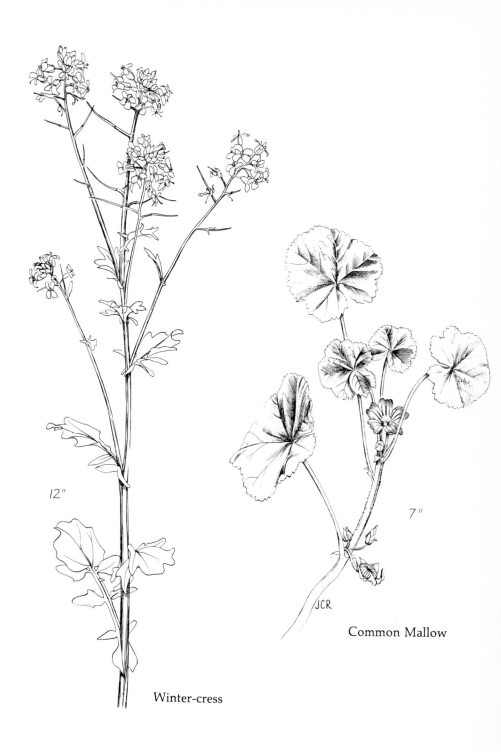

12"

7"

JCR

Winter-cress

Common Mallow

Scrophulariàceae: Snapdragon Family

THYME-LEAVED SPEEDWELL
Verónica serpyllifòlia (St. Veronica) (thyme-leaved)

A miniature perennial, Thyme-leaved Speedwell blooms in lawns and fields in mid-April, forming 3-inch high mats by its creeping habit. The blue or white flowers, seldom more than ¼ inch across with dark blue stripes, are borne singly in the axils of small, leafy bracts. There are four petals, the lowest narrower than the other three and all joined at the base. All the Veronicas (twenty species are listed in Gray) have heart-shaped seedpods whose variations are helpful in separating them; that of *Veronica serpyllifolia* is broader than it is long and is bluntly notched.

The genus is naturalized from Europe where it was named Speedwell by the English because it was thought that the blue flowers along grassy verges wished travelers good speed. Also it was believed to cure the gout (of stay-at-homes?).

MID-APRIL ALIEN

Labiàtae: Mint Family

GROUND IVY, GILL-O'ER-THE-GROUND, RUN-AWAY-ROBIN
Glechòma hederàcea (pennyroyal) (ivylike)

The square stem and aromatic leaves identify the family, while the ground-creeping habit explains the names of this little perennial. Lying on the ground and rooting at the joints, the fragile stems send up flowering branches 3 to 12 inches high that bear roundish, deep green leaves with scalloped margins. From their axils rise the clusters of blue-purple flowers in mid-April. The corolla tube flares into two lips, the upper erect and two-cleft, the lower spreading and three-cleft. There are four stamens, of which the upper two are longer than the lower two and a pistil that is two-lobed at the apex.

Glechoma hederacea may carpet roadsides, damp lawns, gardens and woods—an attractive ground cover or an obstreperous weed, depending upon the eye of the beholder. Naturalized from Europe, Ground Ivy was formerly prized as a tea for treating colds and for flavoring ale.

MID-APRIL ALIEN

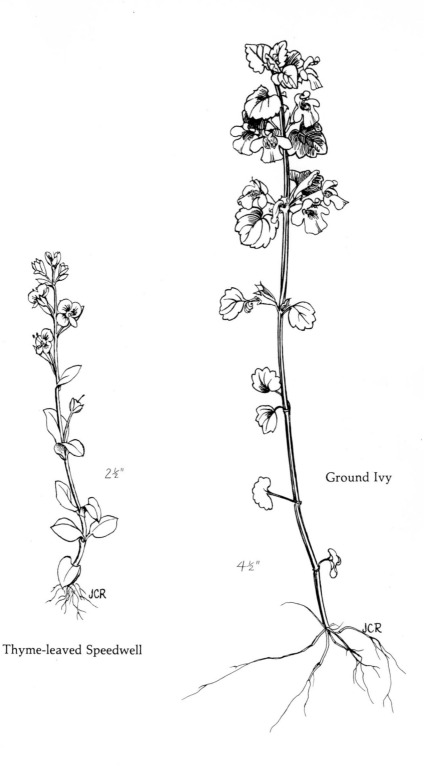

2½"

4½"

JCR

Ground Ivy

JCR

Thyme-leaved Speedwell

Aristolochiàceae: Birthwort Family

WILD GINGER
Asarum canadénse (Greek name) (Canadian)

Woodsy slopes often glisten in May with the lustrous leaves of Wild Ginger. Broad and heart-shaped, they are 3 to 8 inches wide and rise in pairs, on soft-haired stalks; the blades' handsome contours are revealed in the sheen of the silky pubescence of their upper surface; the undersides are downy and a paler green.

The flower is somber in color and reclusive in habit, nodding on a short, down-curving stalk that grows from the fork of the young leaves. This places the flower on or near the ground, but its beauty is well worth stooping to see. Sometimes one must brush aside dead leaves to find the hairy calyx cup of reddish-brown and cream with its long, pointed lobes. Newly hatched gnats, flies and beetles enter this warm place of refuge and leave pollen on the sticky stigma as they enter. In *Asarum canadensis* the pistil matures before the stamens. After the pistil has been pollinated, the six or twelve stamens elongate and mature; their pollen is carried by the insects to a younger plant whose stigma is receptive and cross-pollination is assured.

Wild Ginger is a perennial rising from an elongated rhizome that has a gingery aroma and flavor. Although it is not a relative of the commercial ginger, the dried rhizome was used by American Indians as a flavoring and as a simple tonic. Centuries ago, members of this family were used to induce childbirth—*Aristolochiaceae* is from "childbirth" in Greek.

LATE APRIL NATIVE

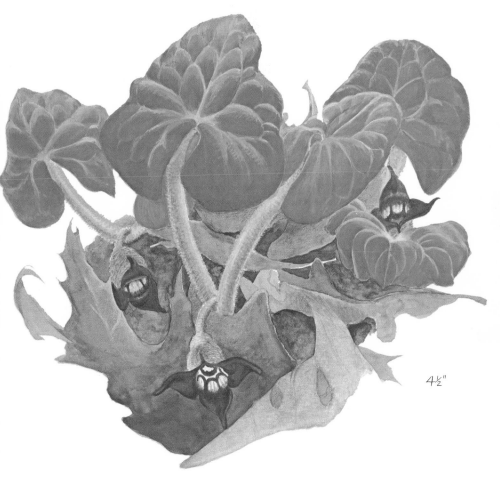

4½"

Wild Ginger

58

Liliàceae: Lily Family

WHITE TROUTLILY, WHITE DOG'S-TOOTH-VIOLET
Erythrònium álbidum (red) (white)

Here is another Troutlily, the white one. Like, and yet different from the Yellow Troutlily, its white perianth has a yellow base and is sometimes tinged with lavender on the outside — occasionally lavender-pink forms are found. The flower hangs from the top of its 4 to 10 inch stem, with the petals and sepals bent sharply upward, so that it does not seem to droop but rather has a dancing or flying-away appearance. The six stamens and one pistil protrude downward from the center under the flower. The smooth leaves are long and slender, delicately mottled in pale greens. The total effect is as graceful as a ballet dancer in a white tutu.

Erythronium albidum blooms in late April in damp wooded areas and on shaded slopes, often in patches. It may be found in company with Violets, Bloodroot or Ginger. The generic name originated with a purple-flowering European species.

LATE APRIL NATIVE

Saxifragàceae: Saxifrage Family

FOAMFLOWER, FALSE MITERWORT
Tiarélla cordifòlia (turban) (heart-leaved)

Blooming in late April or early May in rich wooded areas, Foamflower stands about a foot high, in a full raceme above the leaves. It does indeed appear foamy, due to the ten long stamens that project radially beyond the five petals of each floweret. The pistil has two styles and develops into a fruit with two unequal lobes, the longer lower one cradling the shorter upper one. The leaves are all basal, heart-shaped, and sharply lobed with scattered long hairs above the short ones beneath. The leaves of Miterwort are similar and difficult to distinguish from Foamflower before the flowering stalk appears.

Tiarella, from the same Greek word that gave us our English word *tiara*, is appropriate for such an ornamental flower. However, botanists say that it was so named for the shape of the pistil, thought by Linnaeus, originator of the system of taxonomic classification, to resemble the ancient Persian turban that the Greek word referred to originally.

MITERWORT, *Mitélla diphýlla*, has similar basal leaves but the flower-stalk is taller with a pair of leaves half-way up, and the flowers are smaller and more scattered. They have five petals pinnately fringed, in snowflake fashion.

ALUM-ROOT, *Heùchera americàna*, also has similar basal leaves but a very tall flowering stalk with drooping, bell-shaped little flowers whose orange-tipped anthers and long style project prominently.

LATE APRIL NATIVE

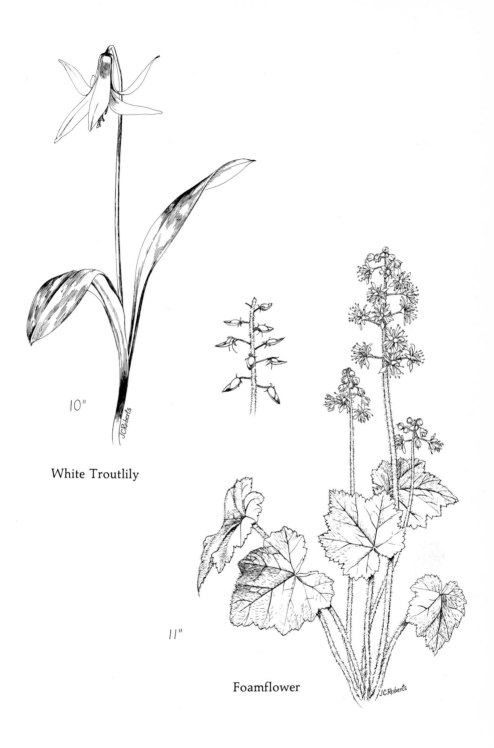

10"

White Troutlily

11"

Foamflower

Lilàceae: Lily Family

LARGE-FLOWERED TRILLIUM, GREAT WHITE TRILLIUM
Tríllium grandiflòrum (three in a whorl) (large-flowered)

A wooded slope set with dozens of these large, showy flowers is a sight to look forward to in late April. The solitary flower has three waxy, white petals, which usually turn a worn pink as they fade, and three green sepals. There are six stamens with long yellow anthers and a six-ribbed ovary with three stigmas. The three large leaves are without stalks, or nearly so, spreading from the top of the erect stem. From their convergence rises the flower-stalk at an angle to the stem below; in any given patch these all slant in the same direction. I have always fancied that this angled flower-stalk developed from the plant's habit of growing on slopes, to allow the flower to face outward.

A mature plant attains 10 to 20 inches, rising from a tuber. Young plants have a single leaf and bear no flower. The fruit is an ovoid black berry, the pistil's six ribs only slightly evident. This is a fickle species with many aberrant forms.

Trillium absorbs energy through its leaves and manufactures food to be stored in the rootstock over the winter in order to grow again another year. Therefore, if picked, the plant will most likely die. From the number that is picked, this must be a little-known fact, but it is one of the reasons that Trillium is protected by law in many states and why the Ohio Department of Natural Resources lists them as being in need of preservation.

LATE APRIL　　　　　　　　　　　　　　　　　　　　　NATIVE

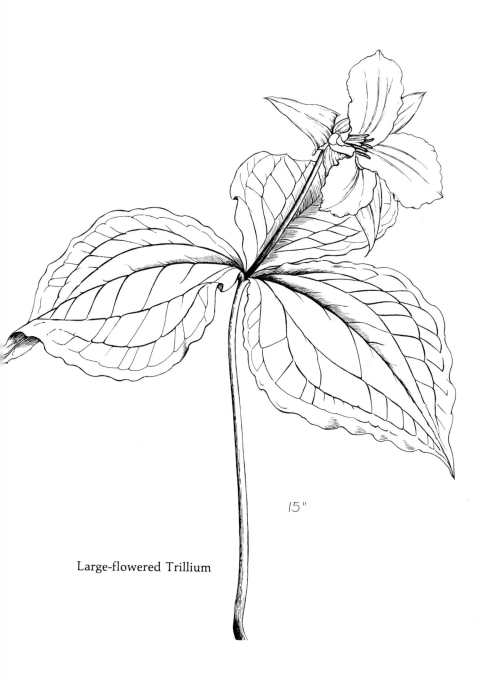

15"

Large-flowered Trillium

62

Caryophyllàceae: Pink Family

FIRE PINK, RED CATCHFLY
Silène virgínica (saliva) (Virginian)

This crimson perennial may brighten open woods or rocky slopes in late April. Its five long petals are usually each split at the end; the ten stamens have gray anthers and white filaments. The stems are apt to be reclining and slightly hairy at the base, then becoming erect and standing up 9 to 18 inches high. In some species the stem hairs are viscid, which accounts for the generic name and the common name Catchfly. All the leaves are on the stalk, mostly low; they are dark green, often edged with red. The many-seeded capsule splits from the top down.

I have found *Silene virginica* blooming with Dwarf Larkspur, Blue Phlox and Violet Wood-sorrel — a red and blue time in the woods.

LATE APRIL NATIVE

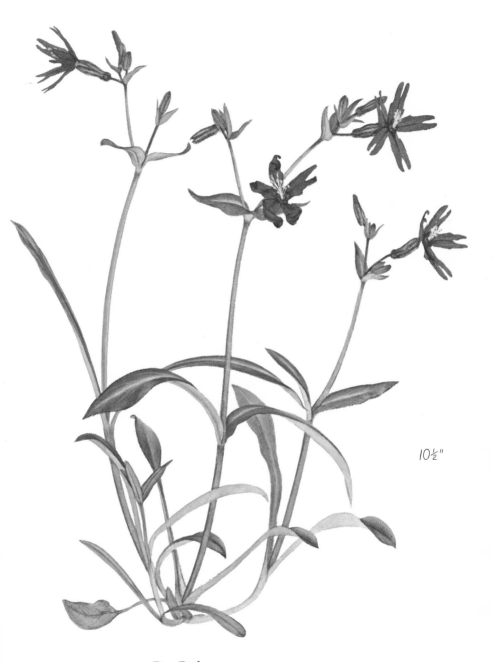

$10\frac{1}{2}''$

Fire Pink

Liliàceae: Lily Family

BENT TRILLIUM, DROOPING TRILLIUM
Trìllium fléxipes (three in a whorl) (bent footstalk)

All twelve species of trillium have an erect stem, a whorl of three leaves and a solitary, three-petaled flower. The color, size, and fragrance vary, as does the flower-stalk; that of Bent Trillium usually curves downward to hold the flower under, or nearly under, the leaves. The white or maroon flower is fragrant and has petals ¾ to 1¾ inches long. There are six stamens with long, cream-colored anthers that stand between the six lobes of the white to pink ovary, each in its own niche. Almost as large as the petals are the three green sepals.

The large leaves are sessile with the usual trillium net-veining. Blooming a little later than Large-flowered Trillium, Bent Trillium also favors woodland slopes and ravines, growing to a height of 15 inches.

Trilliums of all kinds should be protected and preserved. Not only is their habitat diminishing yearly, but they are also being reduced by grazing and picking which kill the plant.

NODDING TRILLIUM, *Trìllium cérnuum*, also has a flower-stalk that curves downward, holding the flower beneath the leaves. It differs in being smaller and having pink anthers.

LATE APRIL NATIVE

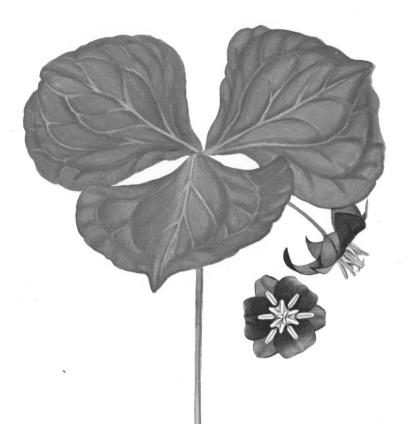

15"

Bent Trillium

Ericàceae: Heath Family

TRAILING ARBUTUS, MAYFLOWER, GROUND LAUREL
Epigaèa rèpens (upon the earth) (creeping)

Pink or white spicily fragrant flowers nestle among the thick, evergreen leaves of Trailing Arbutus in terminal and axillary clusters. The corolla is a short tube that is hairy inside and flares into five lobes. There are ten stamens and a pistil whose style forms a ring around the five lobes of the stigma; the stamens and pistil are often in separate plants. The leaves are alternate, leathery and covered with short bristles, occasionally darkened and splotched with brown.

New leaves will appear after the flowers have faded, when the dark red, spherical fruit is forming. Both leaves and fruit are hairy, as is the rust-colored stem. The plant is found on sandy, woodland banks in late April.

The common names come from two related plants: Mountain Laurel, a shrub in the same family, often nearby, and *Arbutus*, a genus of trees or shrubs, also in the Heath Family, with small white or pink flowers. There are two species in the genus *Epigaea*, and only this one in North America. Unfortunately, it has become rare due to loss of suitable habitat and loss from picking. The stem is so woody and the roots so shallow that efforts to pick the pretty, fragrant flowers result in pulling up the whole plant; and since it won't transplant, it has thus been exterminated from much of its former range.

Whittier's poem "The Mayflowers" describes the Pilgrims finding these flowers after their "fearful winter," gaining hope from them, and naming them Mayflowers. In Plymouth, Massachusetts, they are among the first flowers of spring.

LATE APRIL NATIVE

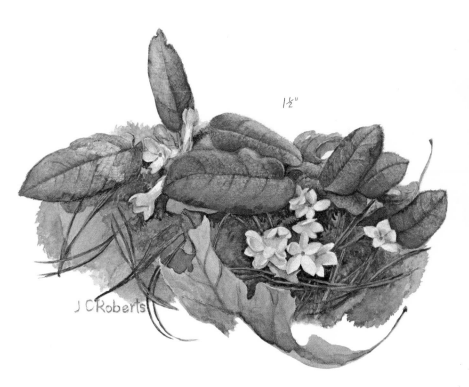

1½"

J C Roberts

Trailing Arbutus

68

Rubiàceae: Madder Family

BLUETS, QUAKER-LADIES, INNOCENCE
Houstònia caerùlea (W. Houstoun) (blue)

Tufts of Bluets are common in fields, lawns and open woods throughout all the eastern states and southeastern Canada, most abundant in New England. The small flowers, ⅓ inch across the corolla, have pale green threadlike stalks 2 to 5 inches high. Arching when the flowers are in bud, the stalks ascend as the buds open to present the flowers (innocent faces) more or less vertically and give them the appearance of being engaged in conversation (Quaker-ladies).

The pale blue to lilac of the flower's four horizontally spreading corolla lobes turns to white at a ringline around the yellow eye; below this the lobes are united into a slender tube. As the flower ages the blue fades, sometimes almost to white. (There is also a white form, *albiflòra.)* The flower has four stamens and one pistil; the fruit is a smooth, two-lobed capsule.

Pairs of miniature leaves grow opposite on the stem and later in rosettes at the base, overlapping each other to form solid mats. Nearby we might find Pussytoes, Violets, Bloodroot or Rue-Anemone blooming. Scattered Bluets may bloom off and on all summer.

Houstonia caerulea has an interesting guard against self-fertilization: the flowers are dimorphous (occurring in two forms); some have short stamens and long pistils, while others have the reverse. Pollen from short stamens fertilizes only short pistils, while pollen from long stamens fertilizes only long pistils.

Houstonia was named for Dr. William Houstoun (1695-1733), an English botanist.

LATE APRIL NATIVE

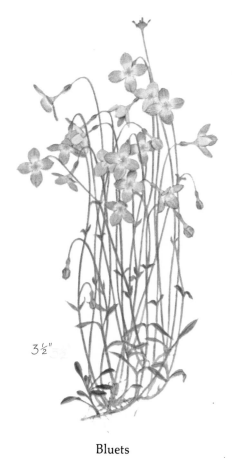

3½"

Bluets

Violàceae: Violet Family

COMMON BLUE VIOLET
Vìola papilionàcea (Violet) (butterflylike)

Sung of by poets for centuries, this is the commonest and perhaps best-loved of the violets, growing in lawns, fields and woods, marking late April as "violet time." The flower is usually deep blue-violet, although paler ones occur and more rarely, white ones. White "beards" on the side petals guard the throat of the spur, or nectar sac. The bottom petal has dark veins, a guide to the nectar. The heavily-veined leaves are heart-shaped with toothed margins, their smooth stalks generally slightly shorter than the 2- to 7-inch flower-stalks.

This and many other violet species have flowers and leaves growing individually from an underground stem and are therefore classed as "stemless." The fruit is a three-valved capsule, opening at the top, each valve holding several seeds.

Blue Violets multiply so successfully, I have read, that "they are almost a weed." A weed is an "unwanted plant" by definition, but to wildflower lovers "weed" designates a wildflower plentiful enough to pick without endangering its continuance; this is especially true of the showy blooms of violets, whose seed seldom survive to germinate. (Later in the season, flowers will form that never open and are self-fertilizing.)

Blue Violets are lovely in a vase, sprinkled on a salad or made into a jelly, as well as a joy to see wherever they are growing. The young leaves are good cooked, alone or with other greens. All parts of the plant are rich in Vitamin C, and the leaves are also rich in Vitamin A. Far from branding this marvelous plant a weed, we should cultivate it on a large scale.

LATE APRIL NATIVE

Violàceae: Violet Family

CREAM VIOLET, PALE VIOLET
Vìola striàta (Violet) (with fine lines)

The petals of Cream Violet are the color of milk or light cream, marked with purple-brown lines. The smooth stems 4 to 12 inches high, often with many branches, are erect, bearing leaves and flowers. The leaves are heart-shaped with rounded teeth; the stipules are green and have toothed margins. *Viola striata* blooms in late April in woods and thickets, when the miniature leaves of trees are beginning to push out of their bud coverings.

The fruit is a smooth, ovoid capsule that splits into three parts, each holding a row of seeds.

LATE APRIL NATIVE

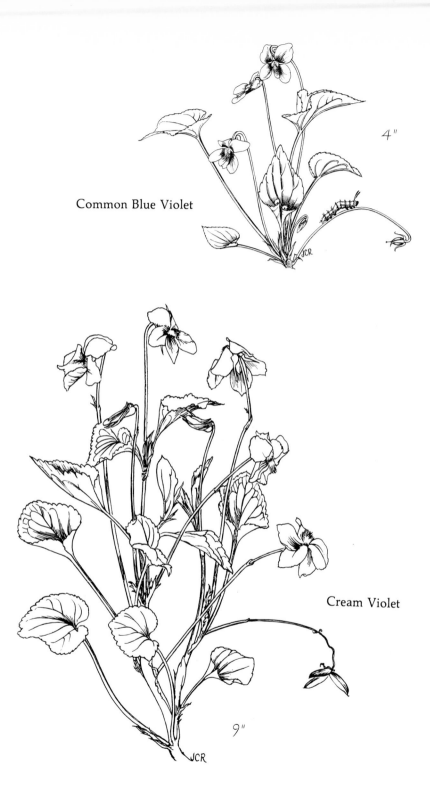

Common Blue Violet

4"

Cream Violet

9"

Ranunculàceae: Buttercup Family

DWARF LARKSPUR, SPRING LARKSPUR, THREE-HORNED LARKSPUR

Delphínium tricórne (dolphin) (three-horned)

Dwarf Larkspur is a stiff perennial of open woods and gravelly slopes, rising from tuberous roots to bloom in late April or early May. The loose raceme of flowers stands 8 to 16 inches tall on a succulent, hairy stem. A long spur, (apparently named for the spur on the back toe of larks), ascends from the base of the uppermost of the five deep blue to purple sepals holding the nectary. Since only long-tongued insects can reach nectar so distant from the mouth of the flower, good pollination is assured with minimum loss of nectar. The two upper petals are white and have spurs within the calyx spur that fits over them like a wrinkled sleeve; the other two petals have fringed claws and make the white, blue or purple "bee" in the center. A white form exists, forma *albiflòrum*, and one in which the purple is variegated with white. There are many stamens and three pistils that develop into many-seeded pods whose ends curl outward to form the three horns of the specific and popular names. The generic name must allude to the shape of the bud, which does resemble a dolphin.

The leaves are mostly basal, palmately cut into five or seven narrow divisions. They are dark green and rough-textured. This lovely plant is for looking at only, since all parts of it are poisonous if eaten, and it is rare and should be preserved (Wistendahl et al., 1975).

LATE APRIL NATIVE

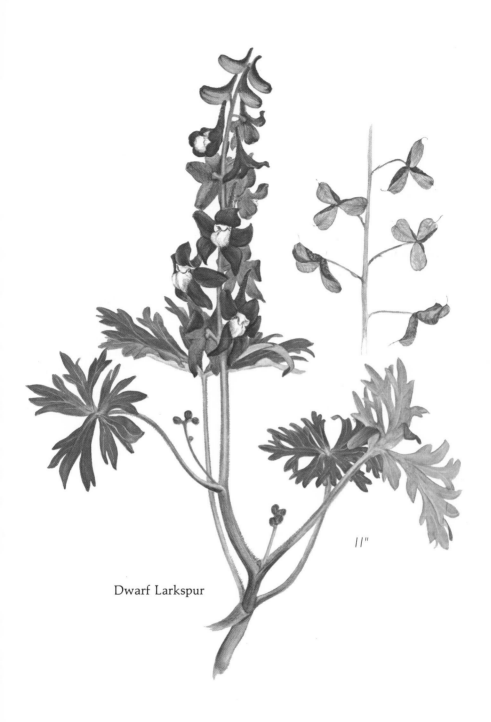

Dwarf Larkspur

11"

Iridàceae: Iris Family

CRESTED DWARF IRIS
Iris cristàta (rainbow) (crested)

 Almost as colorful as a rainbow and ornamented with a yellow and white crest, *Iris cristata* is easily recognized by its resemblance to well-known cultivated irises. Standing only about 4 inches tall, the flowers are purple or blue (rarely pink or white) and come wrapped in a papery envelope or spathe. The three purple petals curve slightly upward and are a solid color; the three sepals curve downward and each bears three parallel bands of crenulations surrounded by a white rectangle bordered in deep blue on a purple field—the crest! The three lavender petal-like parts are three branches of the style, underneath which the anthers are sheltered. A three-angled capsule is formed that is hidden in the spathe.
 Overlapping, bladelike leaves sheathe the flower-stalk. Leaves of sterile shoots overlap one another and by summertime grow to an inch in width and a foot in length, arching gracefully. Lying almost on the surface, the jointed rootstock (said to be very poisonous), puts out slender runners to start new plants—thus a dense patch may result. *Iris cristata* is found in rich woods and ravines and on bluffs in late April.

LATE APRIL NATIVE

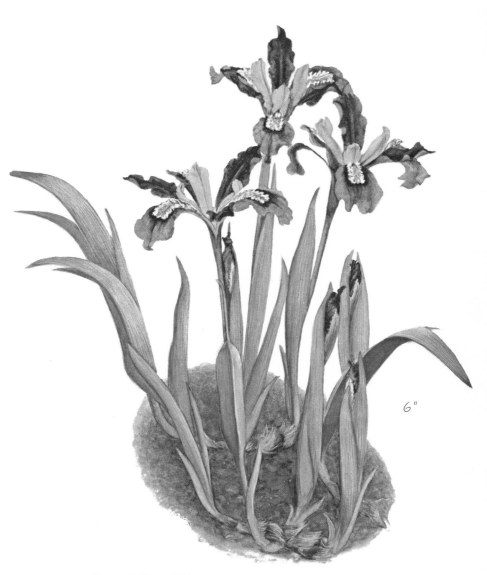

6"

Crested Dwarf Iris

Compósitae: Composite Family

DAISY FLEABANE

Erígeron philadélphicus (early/old man) (Philadelphian)

Several of the genus *Erigeron* are called Daisy Fleabane. *Erigeron philadelphicus* is a short-lived perennial, blooming in late April in thickets, fields, and open woods. The mildly fragrant flower heads have white to pale magenta rays with yellow centers, less than an inch across, at the top of the 6 to 30 inch stem. Alternate leaves clasp the stem; leaves and stem may be hairy or smooth. The generic name refers to the early-flowering of this species and to either the white hairs of the pappus bristles or to the hoary down on the leaves and stems of some species—botanists don't seem to agree.

LATE APRIL NATIVE

Compósitae: Composite Family

GROUNDSEL, GOLDEN RAGWORT, SQUAW-WEED

Senécio obovàtus (old man) (upside-down ovate)

A tall, smooth perennial, this Groundsel may reach a height of 2 feet, with thick basal leaves 1 to 4 inches long and lobed stem leaves that often have woolly tufts in their axils. Deep yellow flower heads are few to many on long slender pedicels; the involucral bracts are purple. Numerous soft, white hairlike bristles form the pappus for which the genus was named. The specific name refers to the shape of the leaf, which distinguishes this species from other members of the large genus *Senecio.*

Groundsel grows on calcareous rocks and gravelly banks, blooming in late April.

LATE APRIL NATIVE

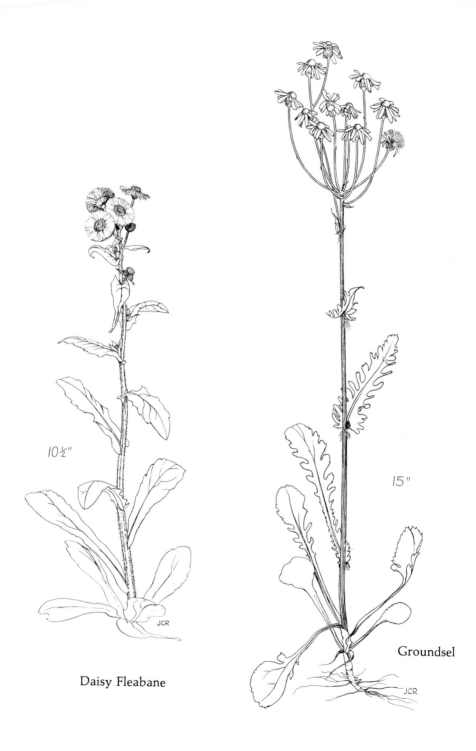

10½"

15"

Daisy Fleabane

Groundsel

Polemoniàceae: Phlox Family

BLUE WOODLAND PHLOX
Phlóx divaricàta (flame) (strongly divergent)

The showy blooms of Blue Woodland Phlox clustered atop the finely-haired stem and its branches, adorn the woods in mid-April with lavender-blue and fill the air with their spicy scent. (A pure white phlox, forma *albiflòra,* exists and is a nice surprise.) The corolla of Blue Woodland Phlox is a narrow tube that flares sharply into five broad lobes. There are five joined sepals, five stamens on the tube, and one pistil with a three-branched style. The pistil matures into a three-valved capsular fruit, each valve holding one seed. The plant may grow to a height of 24 inches. Prostrate basal shoots form, which give rise to new erect stems the following spring.

The Greek word *phlox* means "flame" and was originally applied to the European Scarlet Lychnis of the pink family. The early settlers of North America are thought to have been so homesick that they gave familiar names to plants they found here having the slightest resemblance to those back home.

LATE APRIL NATIVE

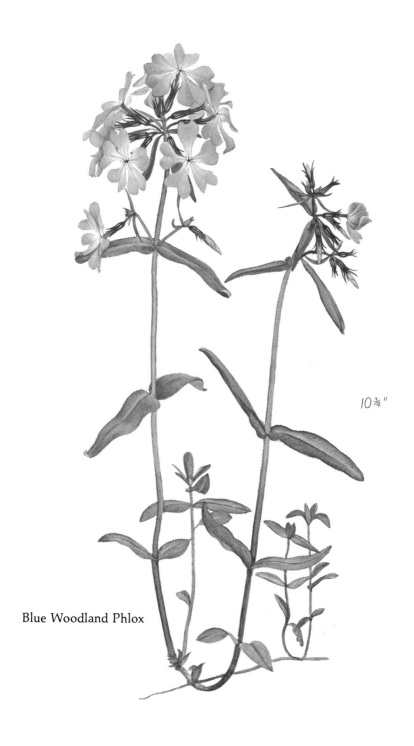

10¾"

Blue Woodland Phlox

Polemoniàceae: Phlox Family

JACOB'S-LADDER, GREEK VALERIAN
Polemònium réptans () (creeping)

The sky-blue color and sweet scent combine with the repeated pattern of the overlapping leaves to make Jacob's-ladder a handsome plant. Five partially joined petals form the bell-shaped flowers that hang in terminal clusters from branching stems. The five stamens with white anthers are slightly shorter than the corolla tube; the style is about the same length as the corolla. The five joined sepals enlarge and enclose the maturing fruit, a three-part capsule, after the corolla drops off.

Although they do not reach all the way to heaven as did the ladder of Jacob's dream, the pinnately compound leaves might be said to resemble ladders; the leaflets are elliptical, smooth above and slightly hairy beneath; the stem is also hairy. Growing to 15 inches tall, Jacob's-ladder blooms in moist, rich woodlands in late April, where Blue Woodland Phlox may be already blooming.

The name *Polemonium* has a disputed origin, but a pleasant sound; *reptans* is obviously a misnomer. Carrion-flower, *Smilax herbacea,* is also sometimes referred to as "Jacob's-ladder."

LATE APRIL NATIVE

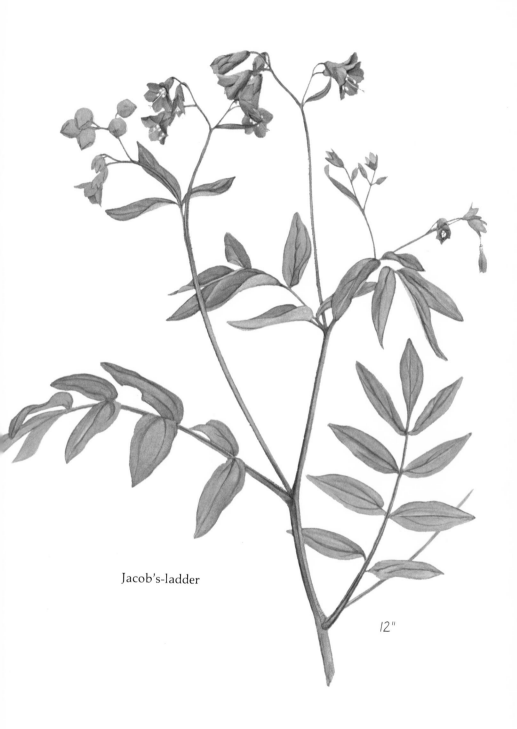

Jacob's-ladder

12"

Violàceae: Violet Family

LONG-SPURRED VIOLET
Vìola rostràta (Violet) (beaked)

Cool, wooded ravines rich in humus often abound in Long-spurred Violets toward the end of April. The lavender petals are beardless, the lower ones with purple veins. The lilac spur is flattened laterally and is the longest among the violets, extending as much as a half inch behind the sepals. The plant grows 4 to 8 inches high with numerous stems that bear both flowers and leaves; the leaves are heart-shaped, becoming longer and more pointed as they mature; the stipules have long teeth. The smooth capsule splits from the top into three parts to disperse its light brown seeds.

LATE APRIL NATIVE

SWEET WHITE VIOLET
Vìola blânda (Violet) (mild)

Sweet White Violet blooms in the same location and at the same time, and often in company with the Long-spurred Violet. The mildly fragrant flower is small, no more than ½ inch across, clear white with purple-brown veins, and beardless. The strongly reflexed upper petals are sometimes slightly twisted. The long scape, tinged with red, carries them well above the leaves, which have deep lobes at the base and are either bluntly heart-shaped or round, with scalloped margins. They are light green on short, reddish petioles. The red-purple capsule is very small. In summer the plant forms slender, leafy runners from which new plants develop.

LATE APRIL NATIVE

THREE-LOBED VIOLET
Vìola trìloba (Violet) (three-lobed)

This woodland violet of late April has rich blue-purple petals, the three lowest ones bearded. The earliest leaves are heart-shaped, smooth or sparingly pubescent, and purple underneath; their petioles are shorter than the flower-stalk. After the flower opens, the three-lobed leaves appear, their undersurfaces and petioles having long, soft hairs. The capsule is ovoid, usually purplish.

LATE APRIL NATIVE

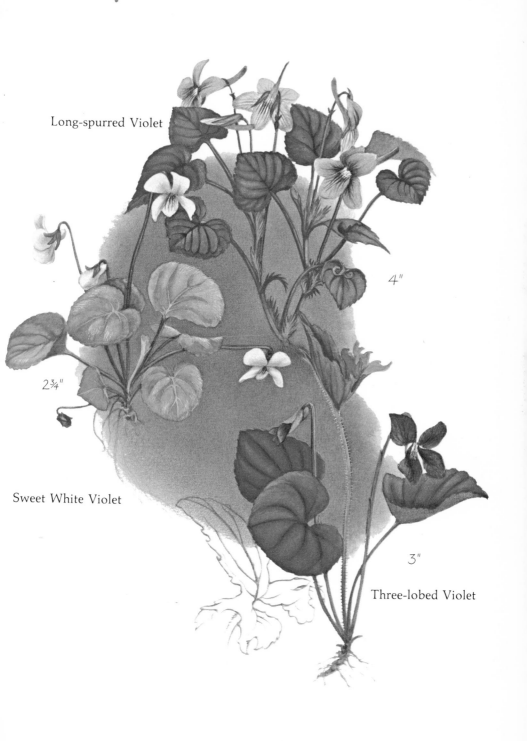

Long-spurred Violet

4"

2¾"

Sweet White Violet

3"

Three-lobed Violet

Ranunculàceae: Buttercup Family

WILD COLUMBINE, EASTERN COLUMBINE, ROCK-BELLS

Aquilègia canadénsis (eagle/to collect water) (Canadian)

Crimson to salmon-pink flowers faced with pale yellow hang from the tips of slender, down-curving pedicels on a plant 1 to 3 feel tall. Long, hollow spurs on the petals extend upward, terminating in bulbous tips that hold the nectaries. The sepals, colored like the petals, alternate with them. The numerous stamens and the style are long, protruding from the corolla. As the flower fades, the pedicel straightens up to hold the ripe fruit erect, each of the five parallel tubular follicles carrying many seeds.

The leaves are thin, two or three times divided into blunt-lobed, glaucous leaflets that are either smooth or slightly pubescent. Rising from a deep, perennial rootstock in open, rocky woods and on shady banks of various soils, *Aquilegia canadensis* blooms in late April or early May. Several races differing in size, color of the flowers, and pubescence occur within this species.

Aquilegia may be from *aquila* (eagle) or from *aqua* (water) and *legere* (to collect), due to the drops of nectar that can be seen in the hollow spurs. In some confusion, this plant is sometimes referred to as Honeysuckle, which, as we all know from the song about it, is a vine — or sometimes a shrub.

LATE APRIL NATIVE

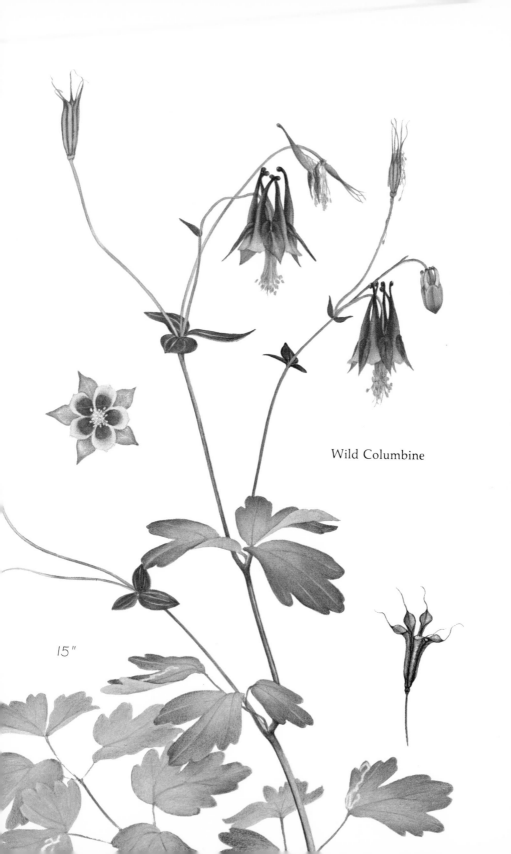

15"

Wild Columbine

Aràceae: Arum Family

JACK-IN-THE-PULPIT, INDIAN TURNIP
Arisaèma atrórubens (blood arum) (dark red)

This unusual-looking flower has a green and purple striped hood or spathe, the top of which curves in canopy fashion over the club-shaped spadix that is 2 to 3 inches high and dark red-brown—the "Jack" in his "Pulpit." Out of sight around the base of the spadix are the minute true flowers, the staminate above the pistillate on mature plants. The flower-stalk is sheathed by the two leaves that are long-stalked and divided into three ovate, asymmetrical, pointed leaflets that are glaucous beneath. Young plants have one leaf and are usually staminate only. The plant rises from a small corm—the "turnip" of the second common name. A perennial of moist woods and shady streamside banks, *Arisaema atrorubens* blooms in early May, ranging up to 2 feet in height.

The fruit, a cluster of ovoid berries seated in a black coblike cylinder, is green at first, then turns crimson in late summer. These berries and the corm are fiery hot if eaten and can cause serious harm; crystals of oxalate of lime are said to be the cause of the burning sensation. American Indians apparently dried the corms and then cooked them for food, but in his *Stalking the Healthful Herbs*, Euell Gibbons says he found it necessary to dry them five months before cooking in order to eliminate the burning sensation. Wood Thrushes and Ringed-necked Pheasants eat the fruit, however, and evidently with no ill effects.

SMALL JACK-IN-THE-PULPIT, *Arisaèma triphýllum*, is similar, although smaller; the leaflets are lustrous and green beneath, and the lateral ones are not noticeably asymmetrical. It flowers two to three weeks later than *A. atrorubens*.

EARLY MAY NATIVE

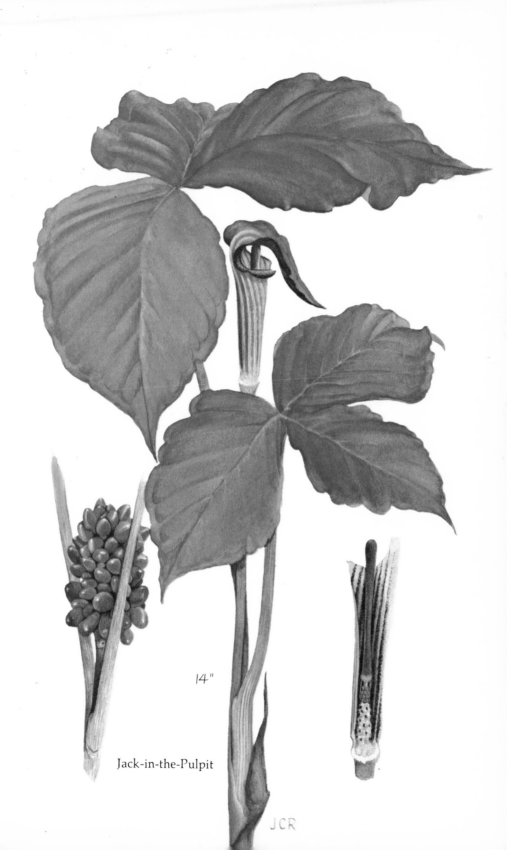

14"

Jack-in-the-Pulpit

JCR

Oxalidàceae: Wood-sorrel Family

VIOLET WOOD-SORREL
Oxalis violàcea (sharp) (violet)

The urn-shaped flowers of Violet Wood-sorrel are bright rose-violet, about ½ inch across in an umbel on a smooth scape 4 to 8 inches tall. The corolla tube flares into five rounded lobes. There are five sepals; a small orange dot (a callosity) brightens the tip of each. The leaves, well below the flowers, are the usual wood-sorrel shape— three-segmented and heart-shaped, but are dark green with deep rose-violet "linings" that the slightest breeze lifting the leaves will show.

Oxalis violacea grows from small bulbs, multiplying by means of runners, thus forming patches. The bulbs, leaves and seeds of this and several other wood-sorrels supply food for wildlife. It blooms in early May in dry, open woods and rocky places, more common southward, whereas the Pink-veined Wood-sorrel (*O. montana*) abounds in cool northern woods. Dwarf Larkspur, Bellwort, Stonecrop and/or Jack-in-the-Pulpit might be blooming in the same place.

See more about *Oxalidaceae* under *Oxalis europaea.*

EARLY MAY NATIVE

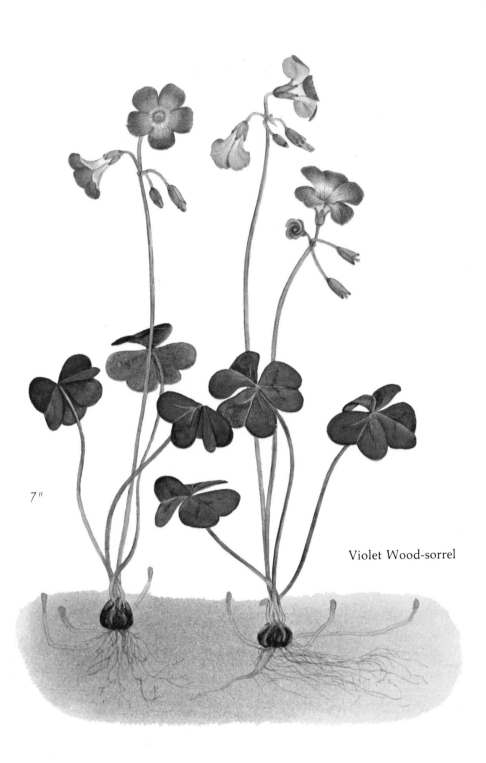

7"

Violet Wood-sorrel

Papaveràceae: Poppy Family

GOLD POPPY, WOOD-POPPY, CELANDINE-POPPY

Stylóphorum diphýllum (style-bearing) (two-leaved)

Golden yellow flowers 2 inches across at the summit of a tall stalk with large lobed leaves—this is the Gold Poppy. There are two bristly sepals, four glossy petals surrounding numerous golden stamens and a pistil whose style is columnar with three or four stigmas. The long style is a distinctive characteristic of this genus, being longer than in most poppies.

There may be several flowers to each plant, their stalks all rising from the fork of the pair of leaves on the stem. These and the basal leaves are divided into five- or seven-toothed lobes, and are smooth above and whitish beneath. The plant has an acrid yellow juice— perhaps another "puccoon" of the Algonquins (see *Sanguinaria canadensis*). It may reach a height of 20 inches, growing in rich open woods in early May.

Gold Poppy, a perennial, is the only species of this genus in North America; the others are Asian. A spring-blooming poppy, it somewhat resembles Celandine, a summer flower of the same family, hence the common name Celandine-Poppy.

EARLY MAY NATIVE

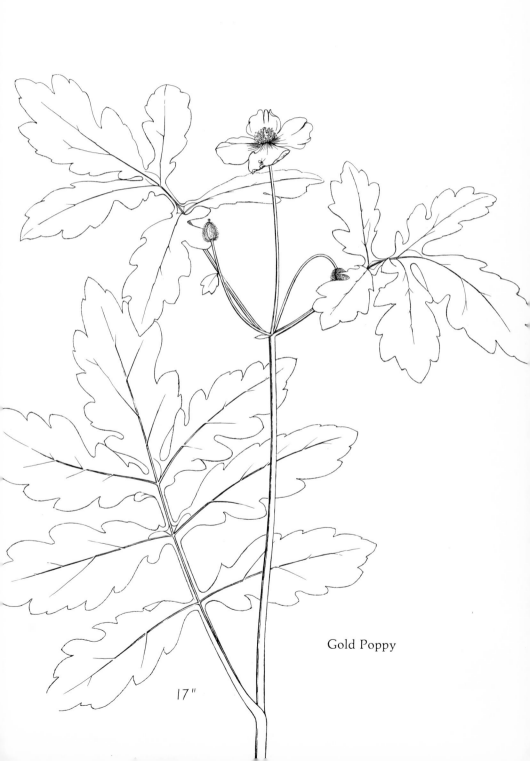

17"

Gold Poppy

Geraniàceae: Geranium Family

WILD GERANIUM, WOOD GERANIUM, CRANESBILL
Gerànium maculàtum (crane) (mottled)

Wild Geranium has a loose cluster of showy rose-lavender flowers 1½ inches across, held above broad dark green leaves by slender stalks—a totally lovely plant. It can be admired for its perfection of design as well: all parts of the plant are in fives—five sepals, five petals, one or two sets of five stamens and a pistil with five styles, each attached to one seed (five seeds). The household geranium of the same family lacks such mathematical consistency.

The buds nod on minutely pubescent pedicels; the sepals are quite hairy. There are several long-stalked basal leaves and two short-stalked stem leaves; all are palmately cut into five or seven sharp-toothed divisions and all have soft white hairs. After the petals fall, the pedicel remains erect to hold the fruit, the "beak", upright; it is composed of the five elongated styles around their elongated axis. When the seeds are mature, each style curls up suddenly like a released spring, catapulting its seed some distance.

Geranium maculatum may attain a height of up to 2 feet in open woods and along shaded roadsides in early May, often where Blue Phlox and Jacob's Ladder are already blooming.

The name Cranesbill came from the long "beak" or "bill" of the pistil; *maculatum* refers to the often spotted appearance of the older leaves.

EARLY MAY NATIVE

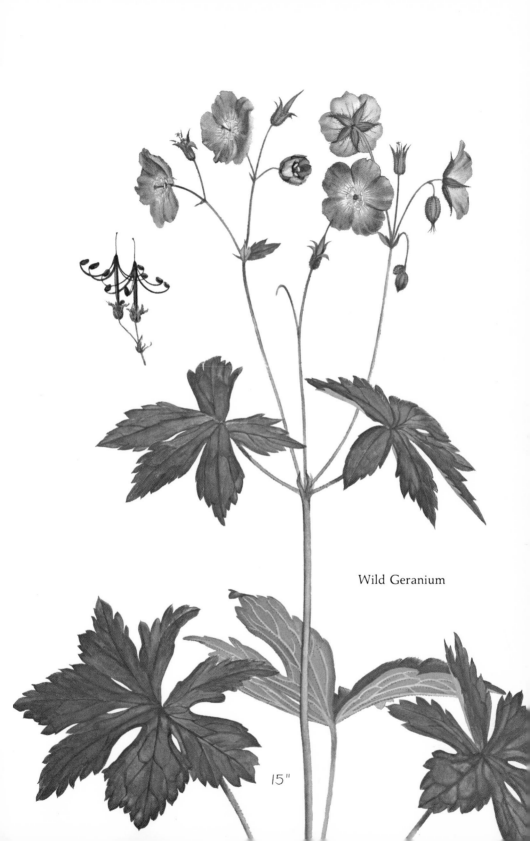

Wild Geranium

15"

Berberidàceae: Barberry Family

MAY-APPLE, WILD MANDRAKE
Podophýllum peltàtum (foot leaf) (shield-shaped)

If no elves are to be found under the green umbrellas of May-apple in May, the beautiful waxy white flowers will be there. In mid-April the closed umbrellas push up through the moist ground of open woods and clearings. As they grow taller, the palmately-lobed leaves open to a foot in diameter on stalks at least 20 inches high, with from four to nine lobes. Growing in close, established colonies, the leaves touch or overlap so as to shade the ground almost completely.

Young plants have a single leaf and bear no flower; but in early May those with paired leaves each bear a large solitary flower, 2 inches broad, nodding on a short stalk from the fork of the two leaves. It has six to nine petals, usually twice as many golden stamens and a pistil with no style, the ruffled stigma sitting directly on the ovary. The flower has a heavy fragrance.

In late summer the ovary matures into an egg-shaped, yellowish fruit, or "apple," that has a citruslike flavor and is sometimes called "wild lemon." Some say the raw fruit is edible, and others speak of disagreeable after-effects. Perhaps, like the persimmon, it must be truly ripe to be palatable. Those I have observed fell off or were eaten before they could become fully ripe, so I can only conjecture. Recipes for May-apple preserves are plentiful.

The leaves and roots are poisonous if eaten, although an extract from them was once used in medicine. This medicinal quality caused the early settlers to name the plant after the Mandrake of Europe, which was used there in medicine and in magic. The generic name is believed to have referred to the stout stem (to botanists the "foot" is always the stem); the specific name refers to the leaf.

May-apple was common throughout the northeast (except along the coastal areas of New England) but is now included in a list of endangered plants (Wistendahl et al., 1975), probably due to its ever-diminishing habitat.

EARLY MAY NATIVE

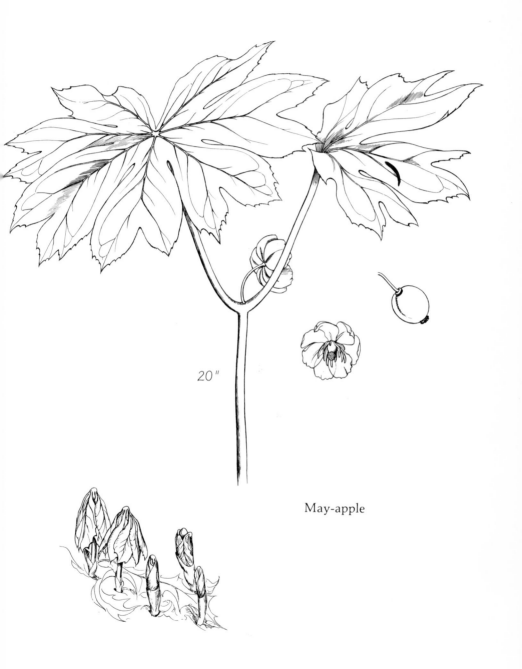

20 "

May-apple

96

Violàceae: Violet Family

CANADA VIOLET
Vìola canadénsis (Violet) (Canadian)

This is a tall, comely violet of moist woodlands throughout most of Canada and the United States. The stem is upright, 1 to 2 feet high, bearing both leaves and flowers. Fragrant and white with a yellow eye, the flower's lowest petal is veined with purple, the two lateral petals are bearded, and the backs of the upper petals are often lilac. The thin, heart-shaped leaves have prolonged tips and serrated margins. The stem has scattered hairs and may be purplish; the stipules are small and scalelike. The capsule is ovoid or almost round and often downy. Canada Violet blooms in early May while several other woodland violets are blooming.

EARLY MAY NATIVE

Rosàceae: Rose Family

WOODLAND STRAWBERRY
Fragària vésca (strawberry) (weak)

The white flowers of Woodland Strawberry, one to nine in a cluster, are on erect, hairy scapes as high as 10 inches and usually exceeding the leaves. There are numerous stamens and many small pistils on a dome-shaped receptacle that develops into a small, red fruit with the achenes borne on the surface. This distinguishes *Fragaria vesca* from the sweet, edible *F. virginiàna* whose achenes are sunken into pits.

The dark green leaves are divided into three leaflets whose edges are deeply toothed; their veining is strong and regular. Woodland Strawberry blooms in woods and along shady roadside banks in early May. Since the plant is firm and stout, the specific name must allude to the flavor of the berry.

EARLY MAY NATIVE

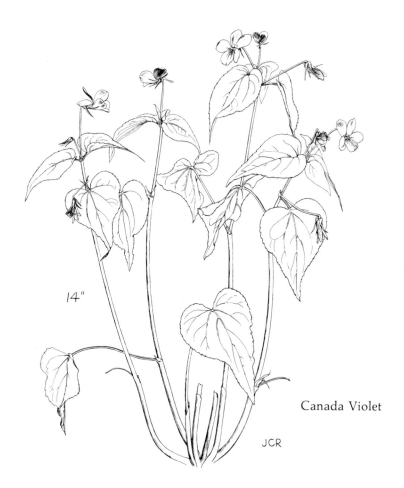

14"

Canada Violet

JCR

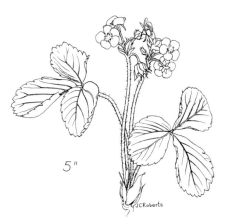

5"

Woodland Strawberry

JCRoberts

Orchidàceae: Orchid Family

SHOWY ORCHIS
Orchis spectábilis (testicle) (showy)

Many of our native orchids have small greenish-white flowers and do not appear as showy as those of the tropics, but this one is all that its name implies. Five to twelve inches high, it has a thick, four-angled stem and two (rarely three) large glossy basal leaves with parallel veining. The fragrant flowers open several at a time, rising from a horizontal to a vertical position, each subtended by a large green bract. The flowers consist of a mauve hood, made up of sepals and petals, and a white lip ½ inch long with a hollow spur extending downward and backward at one side of the flower-stalk. Waxy pollen grains in two masses are adhered by sticky tissue to slender stalks attached to the glands of the stigma. These stick to the smooth cheeks of female bumblebees (the males are not yet hatched) and are thus carried to pollinate the next flower.

Blooming in mid-May, Showy Orchis grows in rich, limy woods. Perhaps the reason we see it so seldom is its susceptibility to attack by slugs and mice. As we might expect, it is listed by the State of Ohio Department of Natural Resources as being rare and in need of preservation. Since orchids require a very specific environment, transplanting is almost never successful—for one thing, molds and other fungi on which they depend will not tolerate new locations.

The generic name is Greek and alludes to the roundish tuberoids of some species.

MID-MAY NATIVE

Labiàtae: Mint Family

HEAL-ALL, SELF-HEAL
Prunélla vulgàris () (common)

The flowers of Heal-all have a rich blue-purple hood and two fringed, lavender lower lips. Beginning in early May several flowers open at once around the thick, cylindrical spike that elongates and may be over 3 inches long by the time all the flowers have opened, faded and fallen off. All the leaves are on the stalk and are hairy underneath. The plant is a perennial 3 to 9 inches tall, shorter in mowed places, taller in unmowed ones. It grows in woods, fields and waste places over all North America.

Introduced from Europe, *Prunella*, a mild astringent, was formerly used as a cure for quinsy (sore throat) and an assortment of other ailments, and to heal wounds. The name *Prunella* is from an uncertain and much-disputed origin, so it is just a name, and a more euphonious one than the common names.

EARLY MAY ALIEN

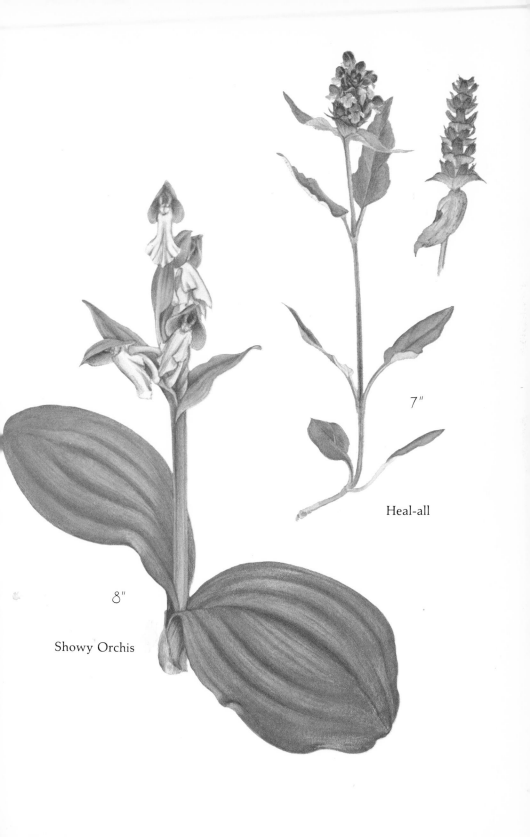

7"

Heal-all

8"

Showy Orchis

Liliàceae: Lily Family

LARGE-FLOWERED BELLWORT, GREAT MERRYBELLS
Uvulària grandiflòra (like a uvula) (large-flowered)

Lemon yellow spiraling sepals and petals hang 1 to 2 inches long from the tips of the drooping forked stem of Large-flowered Bellwort. The six stamens are longer than the style. The nerved leaves, just unfolding as the plant blooms, seem to be pierced by the stem; later they will lift up, eventually exceeding the fruit. They are smooth and cool green above, downy white beneath. The fruit is an obtusely three-lobed pod, which opens at the top.

Growing 1 to 2½ feet tall on wooded slopes, *Uvularia grandiflora* flowers in early May where Violets, Rue-Anemone and Jack-in-the-Pulpit may be blooming. A recent list of endangered species includes this Bellwort (Wistendahl et al., 1975).

"Wort" as a suffix usually just means "plant," although formerly it was attached to the names of plants that were used for food or medicine.

PERFOLIATE BELLWORT, *Uvulària perfoliàta*, although similar, is smaller; the inner surface of the perianth is rough; the stamens are shorter than the style; the leaves are glaucous and its fruit is a three-lobed truncated pod.

EARLY MAY NATIVE

Crucíferae: Mustard Family

ROUND-LEAVED WATERCRESS, MOUNTAIN WATERCRESS
Cardámine rotundifòlia (heart strengthening) (round-leaved)

The four white petals of this cress have the usual mustard family "cross" arrangement and are in a raceme at the summit of the tender, often reclining stems. The petals are ¼ to ⅜ inch long; there are six stamens, two shorter than the others, and a pistil that becomes a narrow pod with many seeds. The stems grow to 10 inches in height. The leaves are rounded; basal ones have long stalks—often with small ears—while those on the stem have very short stalks.

This watercress grows in wet areas near springs and brooks, sometimes actually standing in the water. It blooms in mid-May and seems to be restricted to the Appalachian area.

The edible True Watercress is *Nasturtium officinale* of the same family, but is creeping and usually floats on clear, running water.

MID-MAY NATIVE

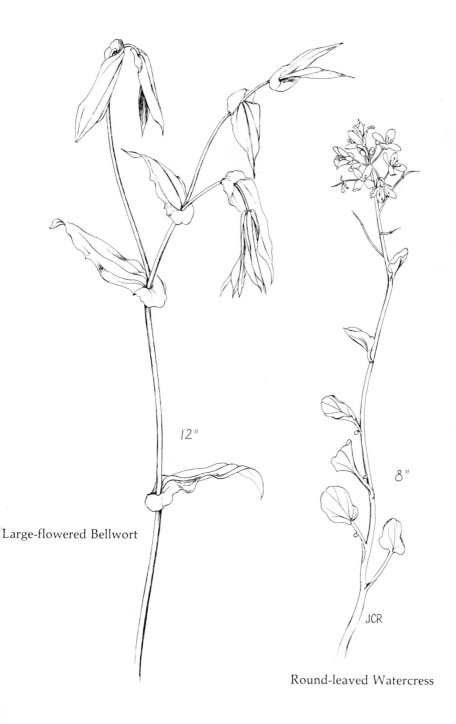

12"

Large-flowered Bellwort

8"

JCR

Round-leaved Watercress

Scrophulariàceae: Snapdragon Family

BLUE-EYED MARY

Collínsia vérna (Z. Collins) (vernal)

Bright blue and white flowers rise on slender stalks from the axils of the upper leaves of this purely American genus. The white upper lip is two-cleft, the blue lower lip three-cleft, although only two segments are apparent; the third is under the other two, folded into an envelope that holds the four stamens and the pistil. The smooth, toothed leaves are opposite on weak stems, the upper ones having pointed tips and rounded basal lobes with which they clasp the stem, while basal leaves are blunt-ended and petioled.

An annual, *Collinsia verna* bears a capsular fruit containing two to four seeds that germinate in autumn. The young plant then remains green over the winter, coming into bloom in early May. It grows on shady roadsides and in open woods, standing 6 to 18 inches high in close colonies.

The genus was dedicated to Zaccheus Collins, a Philadelphian botanist who lived from 1764 to 1831.

EARLY MAY NATIVE

Oxalidàceae: Wood-sorrel Family

YELLOW WOOD-SORREL

Oxalis europaèa (sour) (European)

Whether flower or weed, the widespread Yellow Wood-sorrel is an attractive little plant. I "weed" it from my garden and put the weeded plants in a jug on my windowsill. There isn't a brighter green than these shamrock leaves—they are alive with light and color. The plant grows 3 to 5 inches tall; all parts of the yellow flower are in fives.

The flower-stalk grows from the axil of the leaf, usually holding three flowers on hairy pedicels. At dusk, the leaves, which are divided into three broad, heart-shaped leaflets, fold along the midrib to an angle of about 120 degrees, turning down against the stem to put their backs together for the night.

The fruit is a narrow, hairy pod, more or less upright; the pedicels do not become reflexed. New plants form by runners as well as by seed. Beginning to bloom in mid-May, they continue all summer, growing in lawns and gardens and along roadsides.

The word *sorrel* derives from "sour"; the plant contains oxalic acid, which is poisonous in large amounts but has a pleasant sour taste when a few leaves are added to a salad or soup. The truly edible species is European and does not grow in this country.

MID-MAY ALIEN

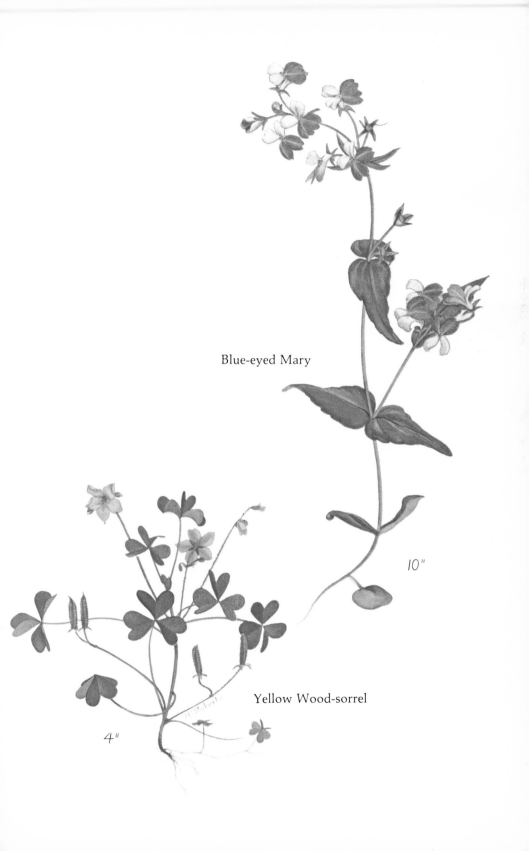

Blue-eyed Mary

Yellow Wood-sorrel

10"

4"

Hydrophyllàceae: Waterleaf Family

APPENDAGED WATERLEAF
Hydrophýllum appendiculàtum (water leaf) (appendaged)

This all-over hairy plant is a biennial of shady, damp woods and banks of streams, ranging from 1 to 2 feet in height. Blooming in mid-May, the bell-shaped lavender flowers, about ½ inch across, are in a loose cluster above the leaves. The corolla is five-cleft and there are five stamens, their purple anthers projecting well beyond the corolla. The calyx is also five-cleft with small reflexed appendages alternating with the sepals.

The broad-bladed maplelike leaves are palmately divided into five pointed lobes and have toothed margins. Some species of this North American family have leaves marked as though stained with water, and the generic name is thought by some to refer to these; however, Gray says that the genus was so named because the original species had very watery stems and petioles.

MID-MAY NATIVE

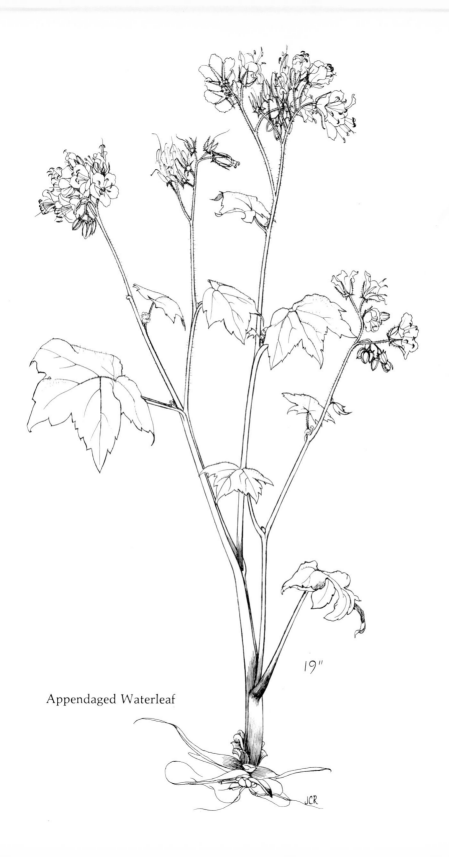

19"

Appendaged Waterleaf

JCR

Commelinàceae: Spiderwort Family

VIRGINIA SPIDERWORT
Tradescántia virginiàna (J. Tradescant) (Virginian)

The three broad petals of Virginia Spiderwort, forming rounded triangular flowers, are usually rich blue, but may be purple, rose or white. There are six stamens with bearded filaments and a pistil with two or three chambers. The flowers, growing in cymes at the summit of the 1- to 2-foot stem open two or three at a time, the buds coiled under at first, uncoiling as they open, recoiling again after the flower passes.

The three sepals are green and have soft, fine hairs, as do the pedicels. Long, narrow leaflike bracts spread beneath the flowers. On the stem are a few broad-bladed leaves longer than the bracts, some of which bend in the middle from the weight of their length—like knees of the "spider's" legs.

Virginia Spiderwort, a perennial, blooms in mid-May along roadsides, woods' borders and gravelly banks. It is native throughout the northeastern quarter of the United States, except in New England, where it was cultivated, but has since escaped. Gray tells us the genus was named for the gardener of Charles I of England, John Tradescant, the Elder, who died in 1637.

OHIO SPIDERWORT, *Tradescántia ohiénsis*, blooms later, has a smooth calyx and stem, and may grow to 3½ feet. Its flowers have a mild old-lavender scent.

MID-MAY NATIVE

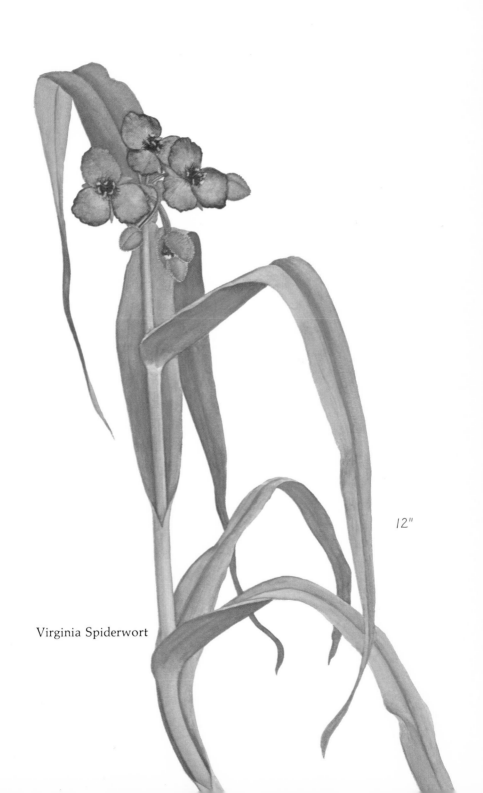

Virginia Spiderwort

12"

Liliàceae: Lily Family

TWO-FLOWERED SOLOMON'S-SEAL
Polygónatum biflòrum (many knees) (two-flowered)

The single, arching stem of Two-flowered Solomon's-Seal stands out sharply from its surroundings. This is the medium-sized *Polygonatum; P. canaliculàtum* is larger with more flowers, and *P. pubéscens* is smaller with minute hairs along the underside of the leaf veins. Two-flowered Solomon's-Seal stands 1 to 3 feet tall; its two (occasionally one or three) yellow-green flowers, which appear in mid-May, hang on slender pedicels from the axils of the leaves. The sepals and petals join into a slim tube with six small, spreading lobes; within are six stamens and a pistil that matures into a dark blue, glaucous berry.

Forming two ranks on either side of the stem, the nerved leaves are sessile, or nearly so, and glaucous beneath. Large patches of Solomon's-Seal may be found in woods and along shaded roadsides.

The generic name refers to the many joints of the rootstock; the common name refers to the scales on the rootstock where the plants of previous years were attached. It was for these scales, which somewhat resemble a King's seal, that the plant was named. King Solomon's Seal (two interlacing triangles that symbolized the union of the soul and the body) was believed to possess magical powers.

MID-MAY NATIVE

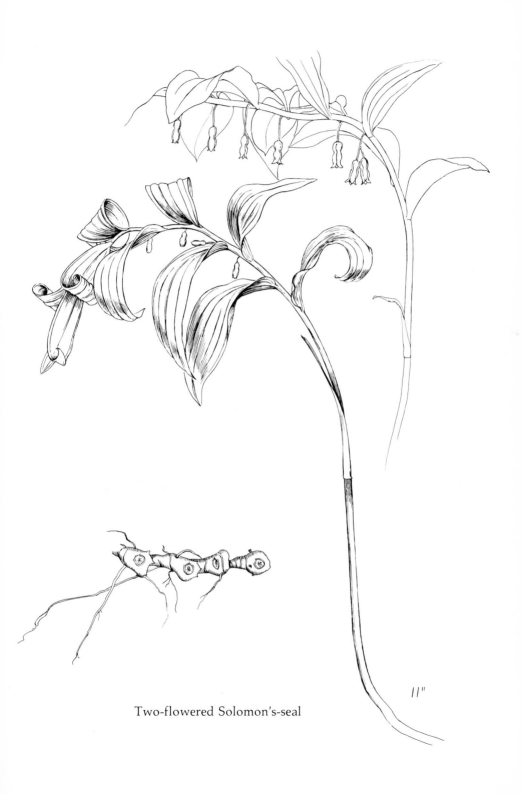

11"

Two-flowered Solomon's-seal

Iridàceae: Iris Family

SLENDER BLUE-EYED GRASS
Sisyrínchium angustifòlium () (narrow-leaved)

Blue-eyed Grass is as charming as its name, for although it is an Iris, not a grass, the characteristic Iris leaves are so small that they blend into surrounding grasses and the deep blue flowers appear to be on the grass itself. In mid-May the plant rises from a small bulb to a height of 6 to 12 inches in fields, meadows and woodland borders. At the top of the winged flower-stalk is a spathe from which a cluster of buds emerges, opening one by one into six-part flowers, whose three sepals and three petals are alike, all rich blue and each with a pointed tip. There is a united center of three stamens and one pistil. Blue-eyed grass is another fair-weather flower, opening only when the sun shines.

The leaves of this species are bladelike, ¼ inch wide and generally shorter than the flower-stalk. The spherical capsules on long pedicels hold numerous spherical seeds (I counted thirty in one capsule), yet there are not nearly that many new plants each year. Probably the seeds are a delicacy to some form of wildlife. It is reassuring to know that the plant has an alternate method of reproducing: if the seeds fail, the bulb may survive and vice versa.

There are nine species of Blue-eyed Grass, each so closely resembling the others as to make little difference to the beginner.

MID-MAY NATIVE

Campanulàceae: Bellwort Family

VENUS'S LOOKING-GLASS
Speculària perfoliàta (of mirrors) (leaf meeting around the stem)

The ½ inch purple or blue five-lobed flowers of Venus's Looking-Glass seem large for the little plant on which they are borne. An annual, the plant grows 6 to 15 inches high. The roundish leaves are bluntly toothed and their basal lobes are cupped around the stem. In the leaf axils are the sessile flowers; the earliest ones (the lowest on the stem) are smaller and do not open, but are self-fertilizing. There are five stamens and a pistil. Soon after the flower fades the inferior ovary matures into a pod holding many tiny seeds. It was for these that the plant was named; they are shiny, elliptical and flattened on one side, but are so small a hand lens is required to see these features.

More interesting to me, and not quite so difficult to see, is the capsule's method of discharging its ripened seeds: three little pores open on three sides of the cylindrical pod by means of valves that roll up, exactly like window shades, allowing the seeds to fall out of the opened windows.

MID-MAY NATIVE

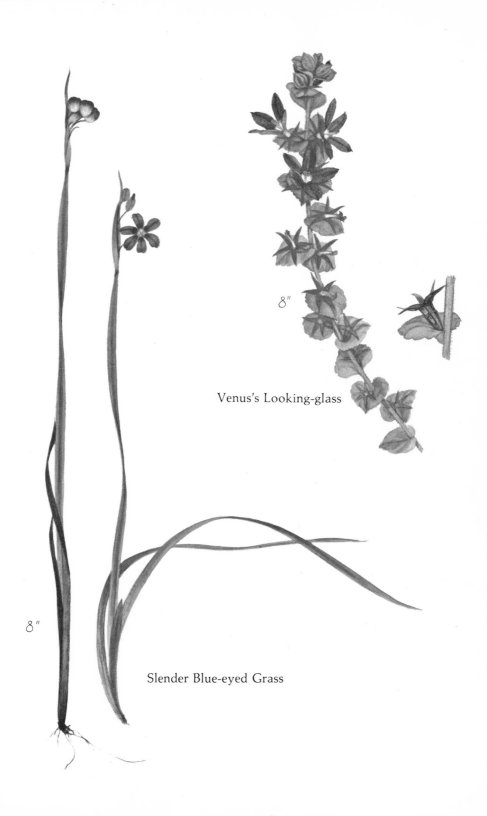

8"

Venus's Looking-glass

8"

Slender Blue-eyed Grass

Caprifoliàceae: Honeysuckle Family

JAPANESE HONEYSUCKLE
Lonícera japónica (A. Lonitzer) (Japanese)

A seductive fragrance emanates from the showy flowers of Japanese Honeysuckle, yet it is a pernicious vine that chokes out native flora, covering and killing everything in its path, even trees. Brought to this country as a planting for highway cuttings, it has become a pest. Unfortunately it is very difficult to eradicate. Constant mowing is fairly successful, but in areas that cannot be mowed a hand-to-hand battle of pulling the honeysuckle up by the roots is the only way, and must be done over a succession of years to be at all effective.

The plant has short-petioled evergreen leaves in overlapping close pairs. In their axils are pairs of tubular flowers with long lobes and longer stamens. White when the buds open, the flowers soon turn yellow. The berries are black, and are a favorite of the birds.

The botanical names refer to a German herbalist, Adam Lonitzer, and to the fact that the plant was introduced into this country from Asia.

LATE MAY ALIEN

Orobanchàceae: Broom-rape Family

ONE-FLOWERED CANCER-ROOT
Orobánche uniflòra (vetch/to strangle) (one-flowered)

All broom-rapes live parasitically on the roots of other plants, two of those in the Old World being Vetch and Broom, one would assume from the names. Not engaged in manufacturing their own food, they have no need for green leaves and are composed simply of a flower and the stalk that holds it; a few scales (vestigial leaves) may be present on the stalk. Having no chlorophyll, the hairy scape of One-flowered Cancer-root is pale and colorless, and the flower is pallid white, lavender or pink with two bearded yellow folds in the throat. The corolla tube flares into five nearly equal lobes—the two of the upper lip are slightly shorter than the three of the lower lip. There are two pairs of two stamens and one pistil with a long style and a large stigma; the minute seeds are numerous.

A fragile flower—even its fragrance is delicate—*Orobanche uniflora* grows in damp woods and thickets in mid-May, parasitic on various woods plants, where several usually rise together from an underground stem.

MID-MAY NATIVE

Japanese Honeysuckle

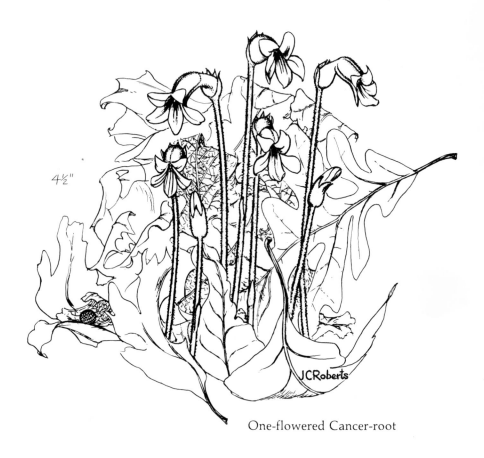

4½"

One-flowered Cancer-root

Leguminòsae: Legume Family

RED CLOVER
Trifòlium praténse (three-leaved) (of meadows)

The familiar Red Clover with its fragrant rosy red flower heads and V-marked leaves abounds. It is cultivated for grazing, hay and soil enrichment and has also escaped into the wild, where it is important as food for wild birds and animals. The flower head is a mass of tubular flowerets and is invested by a pair of almost sessile leaves, each of which is divided into three leaflets. Stem leaves are thrice-divided as well, but have long stalks with stipules joined to the stalk except for their slender free tips. Reaching a height of 8 to 24 inches, it blooms from late May to October in several generations.

Red Clover is almost completely dependent upon the bumblebee for fertilization, since no other bee has the long proboscis necessary to penetrate the deep corolla tube. In *According to Season*, F. T. Parsons relates an amusing old tale which claims that the growth of Red Clover depends largely upon the proximity of old women. Explanation: old women keep cats, cats kill mice, mice destroy bumblebee nests; hence a good supply of Red Clover depends upon an abundance of old women.

LATE MAY ALIEN

Scrophulariàceae: Snapdragon Family

WOOD-BETONY, COMMON LOUSEWORT
Pediculàris canadénsis (a louse) (Canadian)

The hairy Wood-betony is an odd plant—said to be an ancient one, and it looks it! Its two color forms might best be described as "old" yellow (a pale dull yellow) and "old" red (a deep dull red). The flower head is a short, dense spike of tubular, two-lipped flowers, the narrow upper lip shaped like a toothed beak (or a medieval halberd) and the lower lip, three lobed and bent downward. Within the upper lip are the four stamens and one pistil. The calyx—entire (not divided into sepals), with a slit through which the corolla emerges—has long, silky white hairs; these cluster around the spike, again bringing to mind defense gear. The stem hairs become thicker and longer toward the flower head. The thick spike elongates in fruit.

Clustered close under the flower head, the stem leaves are pinnately cut and toothed like a coarse fern. Basal leaves are numerous and often reddish; they have short hairs on the upper surface and longer ones underneath, along the ribs. Wood-betony blooms in mid-May in woods and on shaded slopes, growing 4 to 16 inches high.

The name is derived from an old belief that cattle became infested with lice because they grazed on a European species of this plant.

MID-MAY NATIVE

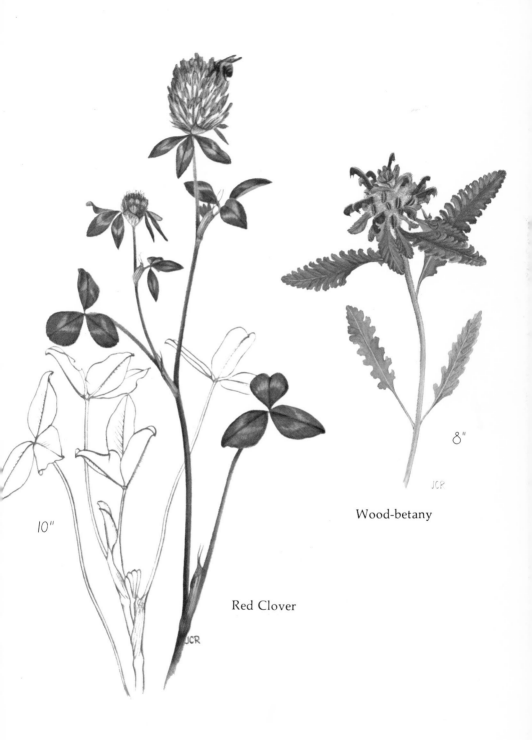

10"

8"

JCR

Wood-betany

JCR

Red Clover

Liliàceae: Lily Family

INDIAN CUCUMBER-ROOT
Medèola virginiàna (Medea) (Virginian)

Indian Cucumber-root is a woodland plant that has a circle of five to nine leaves about halfway up a simple slender stem, and three (occasionally four or five) smaller leaves in a whorl at the top. The 1- to 3-foot stem, shrouded in a white wool when young, rises from a horizontal white tuber, said to have the crispness and taste of cucumber.

Flower buds form in late May in a sessile umbel on top of the upper leaves. Their pedicels elongate as they grow, and curve down to hold the open flower under the leaves. The yellow-green perianth curls back tightly like a tiny tiger-lily, but the three long reddish-brown stigmas and the six down-spreading stamens with red anthers turn the lily into a miniature flying saucer. The fruit is a berry that becomes red-purple in late summer. This is the only species in this genus. The sorceress Medea is said to be the origin of the generic name.

LATE MAY NATIVE

Cruciferae: Mustard Family

DAME'S ROCKET, SWEET ROCKET
Hésperis matronàlis (evening) (matronly)

A tall showy flower looking something like phlox, but having the four petals of the mustards, Dame's Rocket is handsome along roadsides and in moist shady places in mid-May. The assorted purple and white flowers are in a panicle atop a hairy stem that often reaches 3 feet in height. The alternate leaves are oblong, pointed and toothed, pubescent both above and beneath. The seed pods are 1 inch or more long and usually erect.

The spicy fragrance of *Hesperis matronalis* becomes stronger in the evening—whence came the botanical names: *Hesperis*, Greek for evening, and *matronalis*, an old name for "Mother of Evening."

Dame's Rocket is a native of Europe and Asia that has been naturalized in this country, having escaped from gardens here.

MID-MAY ALIEN

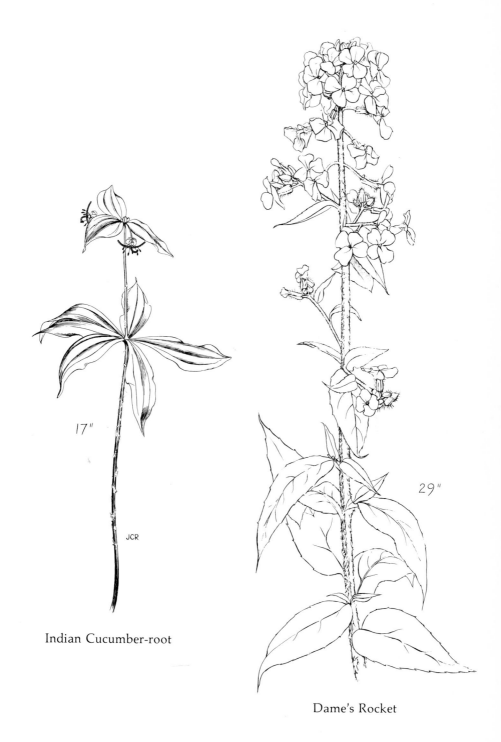

17"

JCR

Indian Cucumber-root

29"

Dame's Rocket

Lilìàceae: Lily Family

STARRY SOLOMON-PLUME, STARRY FALSE SOLOMON'S-SEAL
Smilacìna stellàta (from Smilax) (starry)

Fragrant white flowers grow in a simple raceme at the summit of the single, unbranching stem of Starry Solomon's-plume. The seven to twelve parallel-veined leaves are 2 to 5 inches long, sessile or slightly clasping the erect or arching, zigzag stem, and downy underneath. The plant attains a height of 8 to 16 inches when in bloom in late May.

The six part perianth is made up of three sepals and three petals, alike, which exceed the six stamens and the style. The ripe berries, ¼ inch in diameter, are bronze with a few black stripes. This perennial is especially lovely when growing in masses on moist slopes and riverbanks.

SOLOMON-PLUME (also called FALSE SOLOMON'S-SEAL) *Smilacìna racemòsa*, has a compound raceme of smaller fragrant white flowers on a taller, heavier stem and the leaves are farther apart. The berries are translucent and speckled.

Note: These are attractive, interesting flowers with every right to a name of their own; therefore, I include the common names which call them "false" only for those who may not know them by any other.

LATE MAY NATIVE

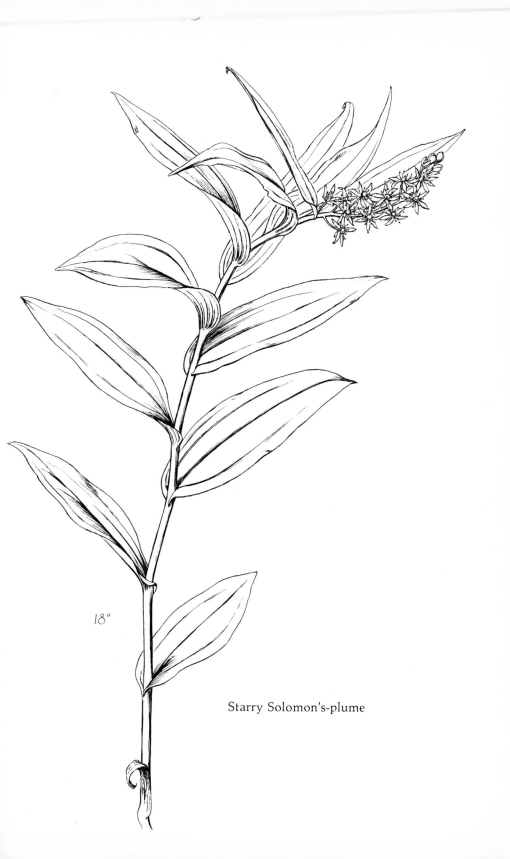

18"

Starry Solomon's-plume

Oxalidàceae: Wood-sorrel Family

GREAT OXALIS, LARGE WOOD-SORREL
Òxalis grándis (sharp) (large)

The creamy yellow blossoms of Great Oxalis may be an inch across, the leaves may be 2 inches broad and the plant can reach 3 feet, yet this largest of the wood-sorrels has a delicate appearance. The parts of the flower are in fives—five each of sepals and petals, five long and five short stamens, and five styles on the ovary. Even the red lines at the neck of each petal are in fives. Usually the blooms are slightly above the three-segmented, heart-shaped leaves, which, in fact, differ from other wood-sorrels only in being larger and a lighter yellow-green, usually with a red-brown edge line. Stems are sparingly pubescent and the stipules are very small. The seed pods are long and narrow, their stalks not deflexed. *Oxalis grandis* is found blooming in late May in woods and on shady slopes.

LATE MAY NATIVE

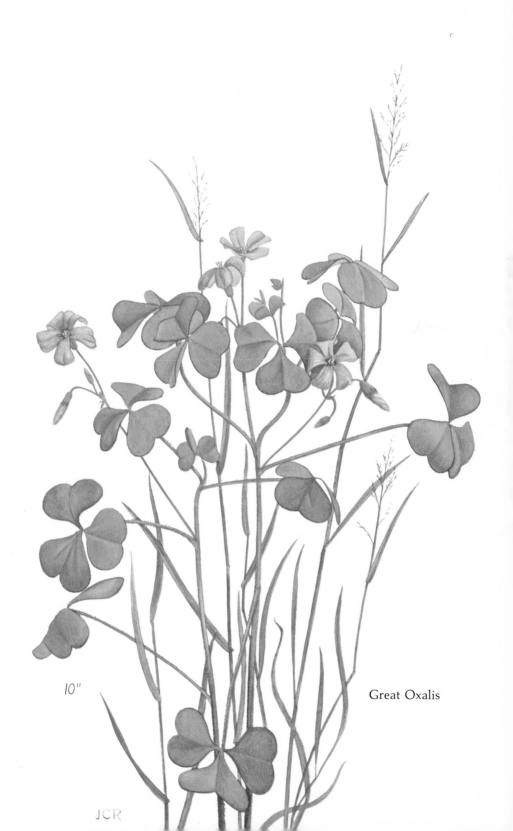

10"

Great Oxalis

JCR

Compósitae: Composite Family

TWO-FLOWERED CYNTHIA
Krígia biflòra (D. Krig) (two-flowered)

Orange is not a common color among spring wildflowers, so Two-flowered Cynthia is a happy sight with its rays, stamens, and pistils all the same glowing yellow-orange. Two or more long-stalked flowers grow from axils of leaflike bracts that clasp the stem. The basal leaves are winged-petioled and sometimes toothed. Bracts, stems and leaves are smooth, glaucous and cool green. The pappus is composed of numerous bristles surrounded by a few small scales.

Krigia bifloria blooms in late May in open woods and thickets and along roadsides among grass. The plant was named in 1791 in honor of David Krig (or Krieg), a physician, who was among the first to collect plants in Maryland.

LATE MAY NATIVE

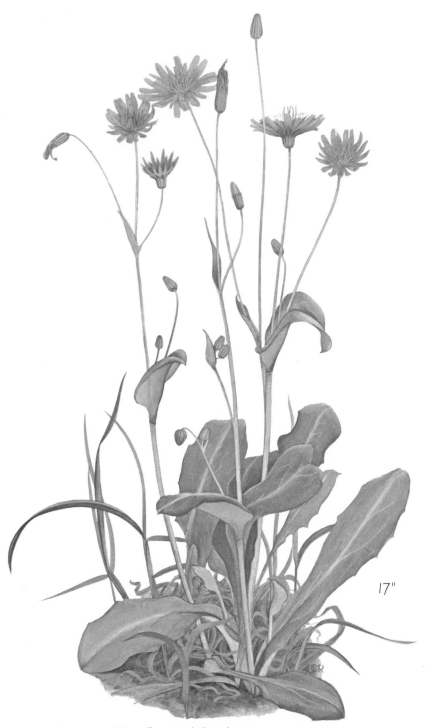

17"

Two-flowered Cynthia

Compósitae: Composite Family

GOAT'S-BEARD
Tragopògon màjor (goat/beard) (larger)

The slender corrugated bud of Goat's-beard opens to a flower of lemon-yellow rays surrounded by long, spokelike bracts. When one knows what is to come, the extra-long bracts are understood, for their length will later be equaled by a beautiful fluffball of feathery pappus bristles, which makes this plant more conspicuous in fruit than in flower—partly because the blossom is open only until noon. The achenes are slender, five to ten ribbed and long-beaked.

Grasslike leaves clasp the hollow stem, which is enlarged just below the flower head. White cottony wisps cling to the stem here and there—the "goat's beard" of the generic name. *Tragopogon major* blooms in fields and along roadsides in late May, the pappus developing soon after.

LATE MAY ALIEN

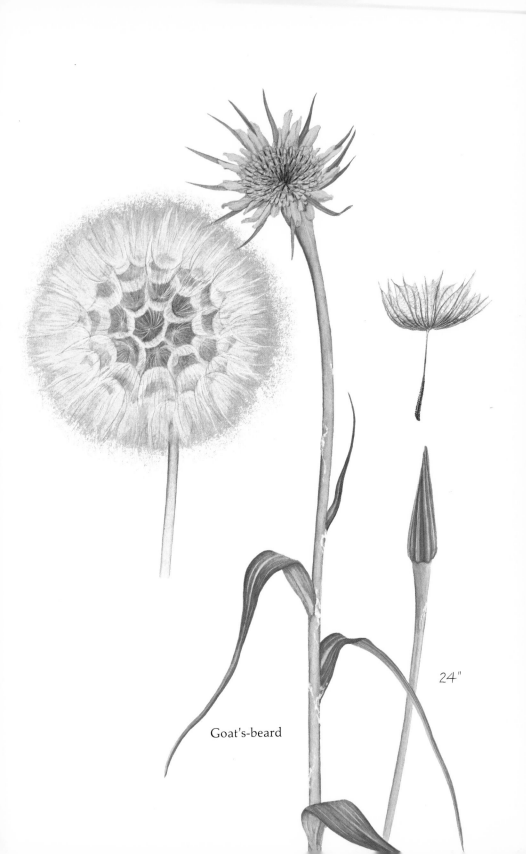

Goat's-beard

24"

126

Leguminòsae: Legume Family

LOW HOP CLOVER
Trifòlium procúmbens (three-leaved) (trailing)

A small plant introduced from the Old World, the yellow Low Hop Clover is found in late May along roadsides and in lawns, fields and waste places. It is only 3 to 6 inches tall, with flower heads ⅓ to 1½ inches broad. When dry, they turn brown and persist until pushed off by the maturing fruit, whose cluster is about the same size and shape as the flower head. The leaves are divided into three-toothed leaflets. The short broad stipules are rounded at the base.

The name "clover" is said to have come from the Latin *clava* (clubs) due to the fancied resemblance of the leaf to the three-pronged club of Hercules.

LATE MAY ALIEN

Rubiàceae: Madder Family

PARTRIDGE-BERRY, TWINBERRY
Mitchélla rèpens (J. Mitchell) (creeping)

A low trailing evergreen plant with shiny round leaves in pairs opposite on the stem, Partridge-berry is a delight all year round. Its scarlet berries remain through the winter to provide food for birds and visual joy for winter hikers. In June fragrant white flowers bloom on the green carpet. Pink in bud and growing from the summit of the leafy branches, the paired flowers have a four-toothed calyx and are funnel-shaped with four spreading lobes that are densely bearded inside. Like its near relative Bluets, Partridge-berry is dimorphous: the four stamens exceeding the pistil in some plants and the pistil exceeding the stamens in others.

The flower pairs are joined at the base, their united ovaries producing one berry that looks exactly like what it is—two berries fused together and crowned by the remains of the two sets of calyx teeth.

Mitchella commemorates Dr. John Mitchell (1676-1768), a Virginian who was an early correspondent of Linnaeus. There are two species of *Mitchella*, ours and one in Japan. The family *Rubiaceae* includes the madder plant from which a red dye is obtained—rose-madder.

EARLY JUNE NATIVE

Low Hop Clover

4"

3"

JCR

Partridge-berry

128

Leguminòsae: Legume Family

PURPLE VETCH, CANADA-PEA
Vícia cràcca (Latin name) (Italian name)

Purple Vetch is a vinelike plant whose own stem, growing as long as 6 feet, cannot support its heavy raceme of handsome flowers and therefore climbs by means of tendrils on other plants and on itself to hold its blossoms in full light at the top of grasses and weeds. The flowers are purple-blue or occasionally white in racemes that grow from the axils of the leaves. The wing petals are joined to the two lower petals, the "keel," and the style has a tuft of hairs at the end—two distinctive characteristics of this genus. The leaves are pinnately compound, those of this species having sixteen to twenty-four segments, each tipped with a tiny point; fine flat-lying hairs cover the surface. The stipules are small and lack teeth. Beginning in early June, Purple Vetch blooms for many weeks.

Because nitrate-producing bacteria live in their roots, vetches are sometimes planted as "green manure" to restore fertility to worn-out soil. Now naturalized in this country, Purple Vetch was originally an emigrant from Europe.

WOOD VETCH, *Vicia caroliniàna*, is a slender native vetch that blooms in early May and whose corolla is white.

EARLY JUNE ALIEN

Caryophyllàceae: Pink Family

DEPTFORD PINK
Diànthus armèria (Jove's flower) (Thrifts)

The stem of Deptford Pink is stiff and erect, like that of its relative the carnation. At the summit is a tight cluster of small flowers with a pair of narrow, pointed bracts beneath each cluster and a similar bract beneath each flower that may be taller than the flower itself. The flowers are deep pink or rose with tiny white spots and toothed edges. There are five petals, ten stamens and a pistil with two styles. The dark green, needlelike leaves stand close beside the stem. The plant is annual and grows 8 to 16 inches high, blooming in late May in lawns, fields and wasteplaces.

The common name came from the town of Deptford, England, where, before industry moved into the countryside, the spring fields were pink with *Dianthus*. The specific name came from an earlier time, when it was placed with the genus *Armeria*, the Thrifts.

LATE MAY ALIEN

30"

Purple Vetch

Deptford Pink

15"

JCR

Ranunculàceae: Buttercup Family

TALL BUTTERCUP, COMMON BUTTERCUP
Ranùnculus àcris (little frog) (acrid)

The buttercups are a large family of perennials found mostly in cool regions and high altitudes. Some grow in water or on wet ground, and it is from these that the family and genus were named "little frog" by Pliny. About an inch across, the flower of *Ranunculus acris* has five green, hairy sepals, five bright yellow petals twice as long as the sepals, a mass of yellow stamens and a knoblike receptacle with numerous green pistils that become achenes with beaks. The petals have a high gloss produced by a layer of cells just beneath the surface. These "bits of butter" dance atop long branching plants up to 5 feet tall.

Divided into five to seven unstalked segments, the leaves are toothed and covered on both sides with hairs, which make them feel like a wool fabric. Their petioles and the lower stem are also thickly haired. The plant has an acrid juice causing it to be bitter.

Ranunculus acris joins Daisies in brightening fields and roadsides in early June. Some species are also called Crowfoot.

EARLY JUNE ALIEN

24"

J C R

Tall Buttercup

Labiàtae: Mint Family

SHOWY SKULLCAP

Scutellària serràta (a dish) (saw-toothed)

Late May woods are shaded and green and no longer witness the parade of wildflowers that marched there earlier. Most of June's flowers are in the open or at the outer edges of woods. Showy Skullcap, one of the last to bloom in the woods at the end of May, is a perennial bitter herb that ranges from 8 to 28 inches tall. Its blue or white flowers are in a terminal raceme, each an inch or more long, turning up abruptly from the calyx to stand erect, in candelabra fashion. The corolla is two-lipped, the upper lip hood-like, the lower one spreading and notched. *(Labiatae* is from the Latin for "lips" and refers to the two liplike parts of the corolla in members of this family.) There are two sepals, the upper having a small hump or "dish" *(scutella),* from which came the generic name and also the common name, the hump on the calyx reminiscent of a skullcap. In maturity the two sepals part like an opened change purse to discharge the nutlets.

The smooth stem is square, a characteristic of the family *Labiatae.* The thin, smooth leaves are in pairs and have serrated margins, alluded to by the name of the species. Unlike most of the family, *Scutellaria* lacks the mint aroma.

LATE MAY NATIVE

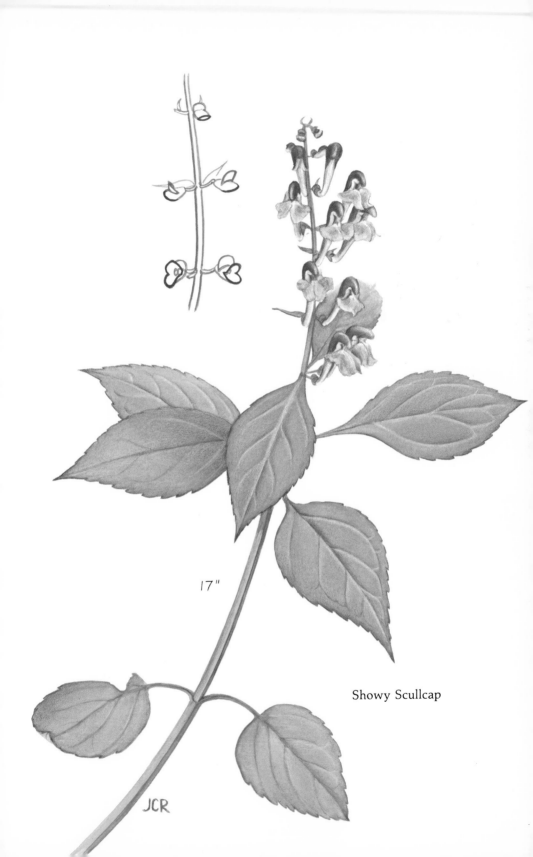

17"

Showy Scullcap

JCR

Scrophulariàceae: Snapdragon Family

HAIRY BEARD-TONGUE
Penstémon hirsùtus (5 stamens) (with stiff hairs)

Penstemon is a large, mostly western, genus of which Ohio has but six species (Weishaupt, 1971). Hairy Beard-tongue has a trumpet-shaped, two-lipped flower that is dull violet with white lobes, of which there are five. There are also five stamens, four fertile and a fifth one sterile; the popular name is for the fifth one which has no anther but is tufted—a palate or a hairy "tongue." The stem, also hairy, has paired sessile leaves; those of the basal rosette are stalked. *Penstemon hirsutus* grows in dry or rocky woods and fields in early June and may reach 3 feet in height.

FOXGLOVE BEARD-TONGUE, *Penstémon digitàlis*, is more common and blooms a week or so earlier. Its stem is smooth and its flower white, sometimes tinged with purple or having purple lines inside.

EARLY JUNE ALIEN

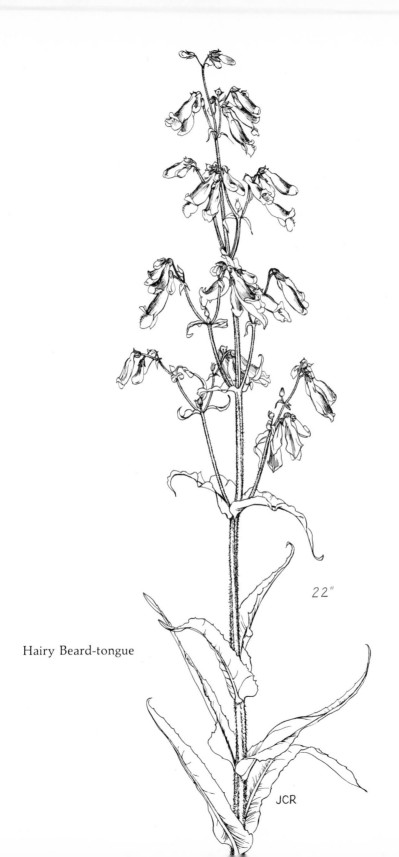

Hairy Beard-tongue

22"

JCR

Compósitae: Composite Family

OX-EYE DAISY, WHITE DAISY, MARGUERITE
Chrysánthemum leucánthemum (golden flower) (white flower)

The pure white rays and the golden disk flowers of Ox-eye Daisy form a head 1½ to 2 inches across that sways in the breeze on a tall, stiff stem 1 to 2½ feet high, in fields and along roadsides in early June. The narrow basal leaves are coarsely toothed, while the sessile stem leaves are fewer, smaller and sharply lobed at the base.

Although a troublesome weed to farmers, Ox-eye Daisy has been admired and esteemed for centures; in Europe its roots were cooked as a potherb and its tender leaves eaten in salads. It was also placed under pillows at night to insure dreams of loved ones. Brought to this country by the earliest settlers, wittingly or not, it is still loved for its bright, fresh beauty and is still asked whether "He loves me" or "He loves me not." Would that all roadways were decked with daisies in June!

EARLY JUNE ALIEN

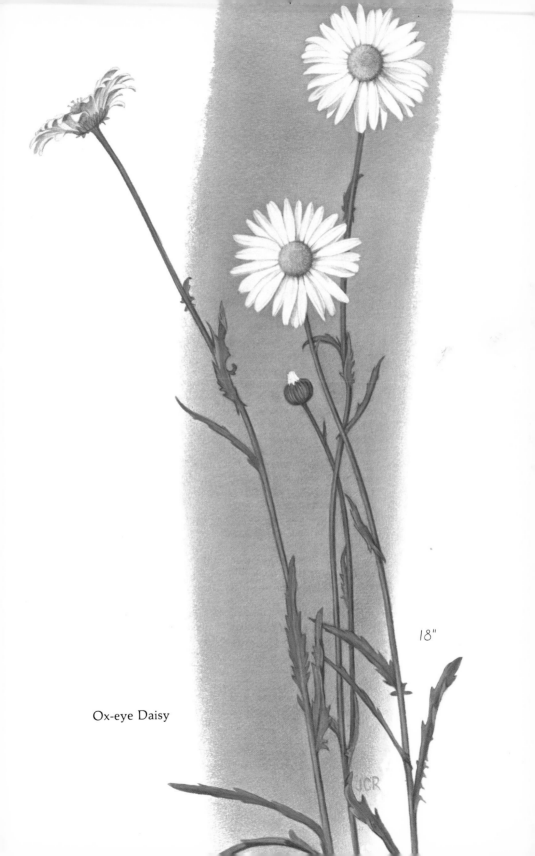

Ox-eye Daisy

18"

J.C.R

Orchidàceae: Orchis Family

PINK LADY'S-SLIPPER, MOCASSIN-FLOWER
Cypripèdium acaùle (Aphrodite's sandle) (stemless)

A rare treat on a late spring walk through the woods is to come upon Pink Lady's-slipper, its pink, bronze and yellow-green colors complemented by the browns of spring earth. All species of *Cypripedium*—whether pink, yellow, white or variegated—have a perianth consisting of three sepals, two united and one separate, and three petals, two lateral and one slipper-shaped.

In Pink Lady's-slipper the solitary 2-inch flower droops from a downy scape that is 2 to 20 inches tall. The sepals and lateral petals are bronzy and the lip is pink or roseate with darker pink veins leading into the fissure down the front; the veins help the bees find this obscure entrance and the incurving edges of the fissure prevent them from leaving from the same opening. Inside the lip-cavity the projecting sticky stigma combs the pollen of another flower from the visitor's head and back. On either side of the column at the tight-fitting exit near the stem are two pollen-bearing stamens that plaster the departing bee with pollen to be "combed out" at the entrance of the next flower. It was Charles Darwin (1809-1882) who first noted such precautions against self-fertilization in his book *Voyage of the Beagle*.

There are two large parallel-veined leaves at the base of the flower-stalk, sheathing it and appearing to be "stemless" because the blades rise directly out of the ground. (The other Lady's-slippers all have leaves on the flowering stem.) The leaves are hairy, 6 to 9 inches long and creased along the parallel veins. A single green bract, like the leaves, but smaller, canopies over the flower. *Cypripedium acaule* grows in strongly acid soil, in sandy or rocky woods, favoring pine woods. Bulbous roots form buds that start new plants, taking several years to produce flowers. Mature plants bloom in June.

This Lady's-slipper is now rare (Wistendhal et al., 1975) due to its reduced habitat and to picking, which kills the plant and may harm the picker. E. Lucy Braun states that the stem and leaves may cause a dermatitis similar to poison ivy if touched.

Cypripedium is from *Cypris*, another name for Aphrodite, the Goddess of Love and Beauty who was born on Cyprus, and from *pedilon*, the word for a Greek sandal. (*Cypripedilum* is the spelling used occasionally.) In any case, whether a Greek sandal, an English slipper, or an American moccasin, the flower wears well and remains loved by all who know it.

EARLY JUNE NATIVE

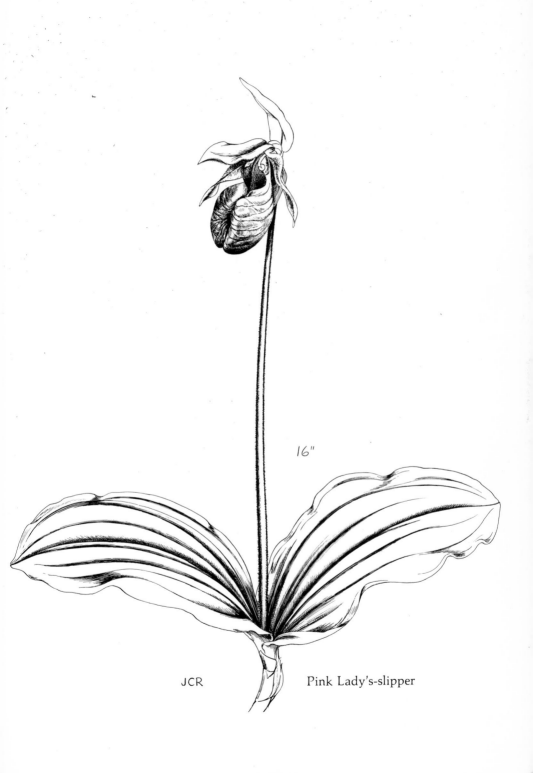

16"

JCR Pink Lady's-slipper

Rosàceae: Rose Family

DWARF WILD ROSE
Ròsa carolìna (Rose) (Carolinian)

The rose family is a large one, ranging from cinquefoil and strawberry to apple and cherry trees and, in early June, to the Dwarf Rose whose sweet fragrance permeates the air. The crepe-textured pink blossoms last only a day, but many buds promise blossoms for many days, and indeed they bloom for many weeks. There are five petals and numerous stamens and carpels. The sepals are united below the lobes into an urn-shaped structure that matures into the small red, fleshy "rose hip," holding the bony achenes.

The flower-stalks grow from the axils of leafy bracts. Long stipules are partially joined to the stalk, leaving their slender tips free. The leaves are divided into 5 or 7 glossy, serrated leaflets. *Rosa carolina* grows 1 to 3 feet tall in dry, open woods, woods borders, and old fields, equally happy under shaded or sunny conditions.

Wild roses produce no nectar and therefore must depend upon pollen-eating beetles to carry some of the sticky pollen on their bodies to other flowers. Seeds are dispersed by wildlife, for whom the hips provide food in winter, when other sources are snow-covered.

EARLY JUNE NATIVE

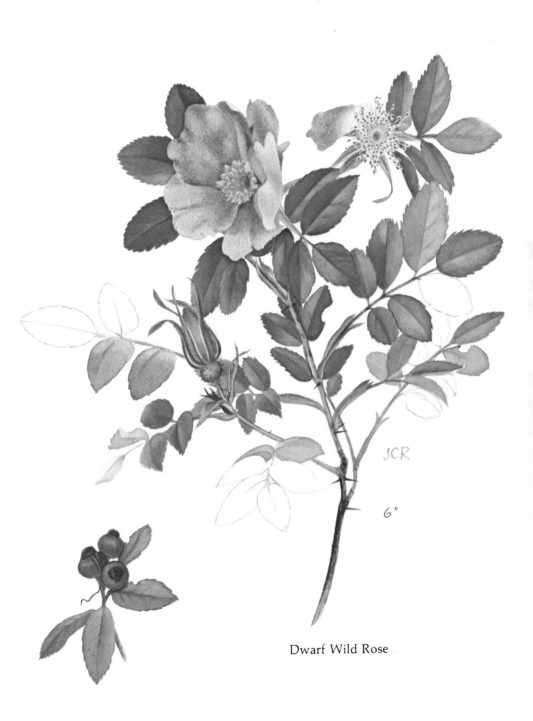

JCR

6"

Dwarf Wild Rose

Commelinàceae: Spiderwort Family

DAYFLOWER
Commelìna commùnis (bros. Commelijn) (growing in colonies)

A weedy plant quite capable of being a nuisance, but having pretty blue flowers, Dayflower creeps on the ground, the stems rooting where leaves are attached and curving up to hold the flowers at the tips. A green spathe, shaped like a wide heart folded in half lengthwise, forms an envelope that holds the buds until they rise out of it to open for just a day. The flower has two bright blue petals standing erect and a third smaller, inconspicuous white one beneath. There are six stamens, three of them fertile and three sterile. The 1½- to 4½-inch leaves sheathing the stem are succulent and lance-shaped.

Commelina communis is found along roadsides, in gardens and on waste ground from late spring through October. According to H. W. Rickett in his *Wildflowers of the United States*, the genus was named "by Linnaeus, with his usual humor, for two Dutch brothers named Commelijn, two of whom (the upper two petals) were botanists of some repute, while the third (the insignificant lower petal), did nothing for the science."

MID-JUNE ALIEN

17"

Dayflower

JCR

Compósitae: Composite Family

BLACK-EYED SUSAN
Rudbéckia hírta (Profs. Rudbeck) (rough)

Rays of yellow-orange surround a dome-shaped disk of dark purple-brown florets—the Black-eyed Susan returns in mid-June to roadsides, fields and grasslands, usually in sterile soil. The large flower heads are held high by long hairy stalks that grow from a stout hairy stem. The toothed leaves are thick and hairy on both sides; upper stem leaves are long, narrow and sessile; lower leaves are broader and have stalks. The fruit lacks pappus bristles.

Rudbeckia was named in honor of Olaf Rudbeck (1630-1702) and his son Olaf (1660-1740) who were predecessors of Linnaeus at Uppsala, Sweden.

MID-JUNE NATIVE

20"

Black-eyed Susan

June Carver Roberts

Compósitae: Composite Family

COMMON CHICORY, BLUE SAILORS
Cichòrium Intybus (Arabic name) (old generic name)

Chicory is really a summer flower, but it always begins to bloom during the last few days of spring. From a deep root rises a stiff, branching plant that may reach 5 feet in height. The nearly stalkless flowerheads are bunched, several together, along the stem. The bright blue rays are square-ended and toothed as though the tips had been cut with pinking shears. "Blue Sailors" perhaps refers to the old-fashioned sailor's hat whose stiff brim had this same sort of jagged edge.

The blue of Chicory fades quickly, and the heads close about noon. Linnaeus built a flower clock that told the time by the opening and closing of the various flowers—I wonder if he had Chicory for a noon-closing one.

This Old-World perennial is now well established in this country, growing in fields and trimming the highways with blue borders. Once cultivated for salad leaves, it is still grown for the root, which is used as a coffee substitute and adulterator.

(Cichorium is pronounced Chicory-um, with the accent on the second syllable.)

LATE JUNE ALIEN

Common Chicory

25"

JCRoberts

GENERA BY FAMILIES

Generic names of plants included in this book
in the logical order of their relationships.

VASCULAR CRYPTOGAMS

Equisetaceae: Horsetail Family
 Equisetum

MONOCOTYLEDONS

Araceae: Arum Family
 Arisaema
 Symplocarpus

Commelinaceae: Spiderwort
Family
 Commelina
 Tradescantia

Liliaceae: Lily Family
 Uvularia
 Erythronium
 Smilacina
 Polygonatum
 Medeola
 Trillium

Iridaceae: Iris Family
 Iris
 Sisyrinchium

Orchidaceae: Orchid Family
 Cypripedium
 Orchis

DICOTYLEDONS

Aristolochiaceae: Birthwort
Family
 Asarum

Caryophyllaceae: Pink Family
 Stellaria
 Cerastium
 Silene
 Dianthus

Portulacaceae: Purslane Family
 Claytonia

Ranunculaceae: Buttercup
Family
 Ranunculus
 Anemonella
 Hepatica
 Aquilegia
 Delphinium

Berberidaceae: Barberry Family
 Podophyllum
 Jeffersonia

Papaveraceae: Poppy Family
 Sanguinaria
 Stylophorum
 Dicentra

Cruciferae: Mustard Family
 Hesperis
 Nasturtium
 Barbarea
 Dentaria
 Cardamine

Crassulaceae: Orpine Family
 Sedum

Saxifragaceae: Saxifrage Family
 Saxifraga
 Tiarella
 Heuchera
 Mitella

Rosaceae: Rose Family
Fragaria
Duchesnia
Potentilla
Rosa

Leguminosae: Legume Family
Trifolium
Vicia

Oxalidaceae: Wood-sorrel
Family
Oxalis

Geraniaceae: Geranium Family
Geranium

Limnanthaceae: False Mermaid
Family
Floerkea

Malvaceae: Mallow Family
Malva

Violaceae: Violet Family
Viola

Umbelliferae: Parsley Family
Erigenia
Osmorhiza

Ericaceae: Heath Family
Epigaea

Gentianaceae: Gentian Family
Obolaria

Polemoniaceae: Phlox Family
Phlox
Polemonium

Hydrophyllaceae: Waterleaf
Family
Hydrophyllum

Boraginaceae: Borage Family
Mertensia

Labiatae: Mint Family
Scutellaria
Glechoma
Prunella

Scrophulariaceae: Snapdragon
Family
Collinsia
Penstemon
Veronica
Pedicularis

Orobanchaceae: Broomrape
Family
Orobanche

Rubiaceae: Madder Family
Mitchella
Houstonia

Caprifoliaceae: Honeysuckle
Family
Lonicera

Campanulaceae: Bluebell Family
Specularia

Compositae: Composite Family
Erigeron
Antennaria
Rudbeckia
Chrysanthemum
Tussilago
Senecio
Cichorium
Krigia
Tragopogon
Taraxacum

GLOSSARY

Achene: A small, dry one-seeded fruit that does not open to discharge the seed, as in buttercup and dandelion.

Alternate: Of leaves, growing one above the next and on the other side.

Anther: The enlarged tip of a stamen, in which pollen is formed.

Axil: Of leaves, etc., the upper angle between a leaf and the stem to which it is attached.

Beak: A firm, prolonged slender tip.

Bearded: Bearing long, stiff hairs.

Berry: A pulpy fruit with immersed seeds, such as a grape. Loosely applied to pulpy fruits bearing seeds on the outside, such as strawberry.

Blade: The broad, flat part of a leaf.

Bracts: Modified leaves in the inflorescence, or on the stalk of a solitary flower, differing from the other leaves of the plant.

Calyx: The outermost circle of flower parts (sepals), which may be separate or joined and are usually green, although sometimes colored like petals. The calyx encloses the other parts of the flower in bud.

Capsule: A dry multiple-seeded fruit that opens along two or more lines when mature.

Carpel: The central female organ of a flower comprising a simple pistil or one section of a compound pistil.

Cleft: Of a leaf blade whose margin is indented at least half way to the midrib, deeper than when notched or lobed and not as deep as when divided.

Cleistogamous: Self-fertilizing in an unopen, budlike state.

Corm: An enlarged fleshy underground base of a stem, bulblike in shape, but solid.

Corolla: The inner circle of floral parts (petals), which may be separate or joined and of any color. The corolla is usually the alluring part of the flower, surrounding stamens and pistil(s).

Cyme: A usually flat-topped inflorescence that blooms from the inside to the outside.

Deflexed: Turned abruptly downward.

Dicotyledon (also Dicot): Any plant of the Dicotyledonae. One of the two major divisions of the Angiosperms or flowering plants, characterized by a pair of embryonic seed leaves that appear at germination. Leaves of Dicots usually have branched veining. Compare Monocotyledon.

Dimorphous: Having two distinct forms.

Disk, disk flowers: In Compositae, small tubular flowers comprising the central portion of the flowering head, differentiated from the straplike marginal ray flowers.

Drupe: A fleshy fruit with a single stony seed, like a cherry.

Entire: Continuous, not interrupted by cuts or lobes.

False raceme: An inflorescence resembling a raceme but whose pedicels all grow from one side of the stem, bending to right and left around the stem, and whose bracts, when present, are *opposite* the pedicels. The stem is often coiled.

Fertile: Capable of producing fruit.

Filament: The stalk of a stamen, which supports the anther.

Floret: A small flower, usually one of a cluster.

Follicle: A dry fruit, consisting of a single carpel that opens along one line (as opposed to more than one) to discharge its seed.

Fruit: A mature carpel or carpels, bearing the seeds. It may be dry or fleshy, edible or inedible.

Genus: A category of taxonomic classification designating a division of a family. Adjective: generic.

Glabrous: Smooth, without hairs.

Glaucous: Covered with a whitish coating or bloom.

Herb (herbaceous): A plant with no persistent woody stem above ground. Also applied to plants used in seasoning or medicine.

Inflorescence: A group or cluster of flowers on a plant, having one of several arrangements (see raceme, panicle, umbel, spike).

Involucre: A circle of bracts surrounding a flower cluster or the head of a single flower.

Leaflet: A single division of a compound leaf.

Lip: Each of the upper and lower divisions of a bilateral corolla or calyx.

Lobes: Segments projecting between indentations, as of a corolla tube or leaf blade.

Monocotyledon (also Monocot): Any plant of the Monocotyledonae, one of the two major divisions of the Angiosperms or flowering plants, characterized by a single embryonic seed leaf that appears at germination. Leaves of Monocots are usually nerved.

Nerve: A leaf vein or rib that is unbranched, as are the leaves of most Monocots.

Node: The place on a stem that usually bears a leaf or whorl of leaves.

Opposite: Of leaves, growing in pairs on either side of the stem.

Ovary: The hollow basal part of a pistil, containing the ovule(s) that later become the seed(s).

Panicle: An inflorescence in which the pedicels are branched, such as in a compound raceme.

Pappus: A tuft of fine bristles surmounting the achene in certain plants such as dandelions, which act as parachutes to carry the achenes on the wind.

Pedicel: A small stalk bearing an individual flower in an inflorescence.

Perianth: The floral envelope surrounding the stamens and pistil(s), composed of the calyx and the corolla·when present.

Persist: Last, continue, as a calyx upon the fruit, or leaves through the winter.

Petal: An individual part of the corolla when it is divided. The petals may be any color and surround the stamens and pistil(s).

Petiole: The stalk supporting a leaf blade.

Pinnate: Of a leaf, compound, having leaflets in a featherlike arrangement on either side of a common midrib, as in vetch.

Pistil: The central, female organ of a flower composed of the seed-bearing ovary and the stigma which receives the fertilizing pollen, and a style, when present, supporting the stigma.

Pistillate: Of flowers with pistils but no stamens.

Pollen: The fertilizing powder borne on the anther.

Pollination: The fertilizing of a flower by the transfer of pollen from an anther to a stigma.

Pubescent: Covered with soft downy hairs.

Raceme: An elongated cluster of flowers on about equally-long pedicels that are arranged on a common stem. Often each pedicel grows from the axil of a bract.

Rare: As applied to wildflowers, those that occur in less than five counties or those that occur in dangerously few numbers anywhere.

Rays, ray flowers: In Compositae, the straplike marginal flowers, differentiated from the central disk flowers.

Receptacle: The tip of the flower-stalk to which the floral parts are attached.

Rhizome: A horizontal underground stem, often short and thick.

Rosette: A cluster of leaves, etc., in a circular form.

Scale: A thin, dry membranous body, usually of a degenerate leaf.

Scape: A naked flowering stem.

Sepal: An individual part of the calyx when it is divided. The sepals may be green or colored as petals, and enclose the other parts of the flower in bud.

Serrated: Having sharp forward-pointing teeth.

Sessile: Having no stalk of any kind.

Sheath: The tubular base of a leaf surrounding a stem.

Spadix: An inflorescence in the arum family whose tiny sessile flowers are borne on a thick, fleshy axis.

Spathe: A bract or several bracts that enclose an inflorescence.

Species: A category of taxonomic classification designating a division of a genus. Adjective: specific.

Spike: A simple inflorescence whose flowers are sessile, or nearly so, along a common stem.

Spur: A hollow tubular extention of a part of a flower, usually producing nectar.

Stamens: The male organs of a flower, of which there are always more than one, usually several to many. A stamen is composed of a slender stalk (filament) and a variously-shaped pollen-bearing tip (anther).

Staminate: Of flowers with stamens but no pistils.

Stigma: The part surmounting a pistil, usually supported by a style, which receives the pollen for effective fertilization. It is rough, sticky, grooved or otherwise modified to catch and hold the pollen.

Stipules: Small paired leaflike appendages at the base of a leaf.

Style: The slender stalk of a pistil that bears the stigma. Occasionally the style is lacking and the stigma is borne directly on the ovary.

Tuber: A thickened underground branch bearing buds.

Umbel: An inflorescence whose pedicels all radiate from the same point, like the ribs of an umbrella.

Veins: Vascular bundles that form the branching framework and support of a leaf.

Whorl: An arrangement of three or more leaves, etc., radiating from the same point.

BIBLIOGRAPHY

Birdseye, Clarence and Eleanor. *Growing Woodland Plants*. 1951; reprint ed., New York; Dover Publications, 1972.

Braun, E. Lucy. *The Monocotyledoneae*. Columbus: Ohio State University Press, 1967.

Britton, Nathaniel Lord, and Brown, Hon. Addison. *An Illustrated Flora of the United States and Canada*. 1913; reprint ed., 3 vols. 2d ed. rev. New York: Dover Publications, 1970.

Comstock, Anna Botsford. *Handbook of Nature Study*. New York: Comstock Publishing Co., 1939.

Core, Earl L. *Plant Taxonomy*. Englewood Cliffs; New Jersey: Prentice-Hall, 1955.

Cuthbert, Mable Jaques. *How to Know the Spring Wildflowers*. Dubuque, Iowa: Wm. C. Brown Co., 1949.

Dana, Mrs. William Starr. *How to Know the Wild Flowers*. 1893; reprint ed. of rev. ed. of 1900, New York: Dover Publications, 1963.

Darwin, Charles. *The Voyage of the Beagle*. Reprint ed., New York: Bantam Books, 1972.

Easterly, N. William. "Distribution Patterns of Ohio Cruciferae," *Castanea* 29 (September 1964):164-73.

Fernald, Merritt Lyndon. *Gray's Manual of Botany*. 8th ed. rewritten and expanded, New York: D. Van Nostrand Co., 1970.

Gibbons, Euell. *Stalking the Healthful Herbs*. New York: David McKay Co., 1966.

Gibbons, Euell. *Stalking the Wild Asparagus*. New York: David McKay Co., 1962.

Grehan, Farrel, and Rickett, H. W. *The Odyssey Book of American Wildflowers*. New York: Odyssey Press, 1964.

Kamm, Minnie Watson. *Old Time Herbs for Northern Gardens*. 1938; reprint ed., New York: Dover Publications, 1971.

Martin, Alexander C.; Zim, Herbert S.; and Nelson, Arnold L. *American Wildlife and Plants*. 1951; reprint ed., New York: Dover Publications, 1961.

Ohio, Department of Natural Resources. "Ohio Wildflowers." n.d.

Parsons, Francis Theodore. *According to Season*. New York: Charles Scribner's Sons, 1902.

Peterson, Roger Tory, and McKenny, Margaret. *A Field Guide to Wildflowers of Northeastern and North-central United States*. Boston: Houghton Mifflin Co., 1968.

Rickett, Harold William. *The New Field Book of American Wild Flowers*. New York: G. P. Putnam's Sons, 1963.

Rickett, Harold William. *Wild Flowers of the United States*. New York: McGraw-Hill Book Co., 1965.

Rohde, Eleanour Sinclair. *A Garden of Herbs*. 1936; reprint ed., New York: Dover Publications, 1969.

Sargent, Charles Sprague. *Manual of the Trees of North America*. 1922; reprint ed., New York: Dover Publications, 1965.

Strausbaugh, P. D., and Core, Earl L. *Flora of West Virginia*, Parts I-IV, West Virginia University Bulletin Series 52, 53, 58, 65. Morgantown, W. Va.: West Virginia University Press, 1952-64.

U.S., Department of Agriculture, Agricultural Research Service. *Common Weeds of the United States*. 1970; reprint ed., New York: Dover Publications, 1971.

Weishaupt, Clara G. *Vascular Plants of Ohio*. 3rd ed. Dubuque, Iowa: Kendall/Hunt Publ. Co., 1971.

Wharton, Mary E., and Barbour, Roger W. *A Guide to the Wildflowers and Ferns of Kentucky*. Lexington: University Press of Kentucky, 1971.

Wherry, Edgar T. *Wild Flower Guide*. n.p.: Doubleday & Co., 1948.

Wistendahl, Warren A.; Wistendahl, Jean D.; and Lewis, Kenneth P. "Rare and Endangered Plant Species of the Central Ohio Valley." Paper presented at the annual meeting of the Ohio Academy of Science. April 1975. Columbus, Ohio. Mimeographed.

Wright, Mable Osgood. *Flowers and Ferns in Their Haunts*. London: Macmillan Co., 1907.

INDEX

158

Roberts, June Carver.
 Born in the spring : a collection of
spring wildflowers / by June Carver
Roberts. Athens : Ohio University Press,
[c1976].
 159 p. : ill. (some col.) ; 24 cm.
 Bibliography: p. 155-156.
 Includes index.

 1. Wild flowers--Ohio--Identification.
I. Title
 86
 ° X
PJo JOCCxc 75-36979